g. deChirico

Great Modern Masters

De Chirico

General Editor: José María Faerna

Translated from the Spanish by Diane Cobos

CAMEO/ABRAMS

HARRY N. ABRAMS, INC., PUBLISHERS

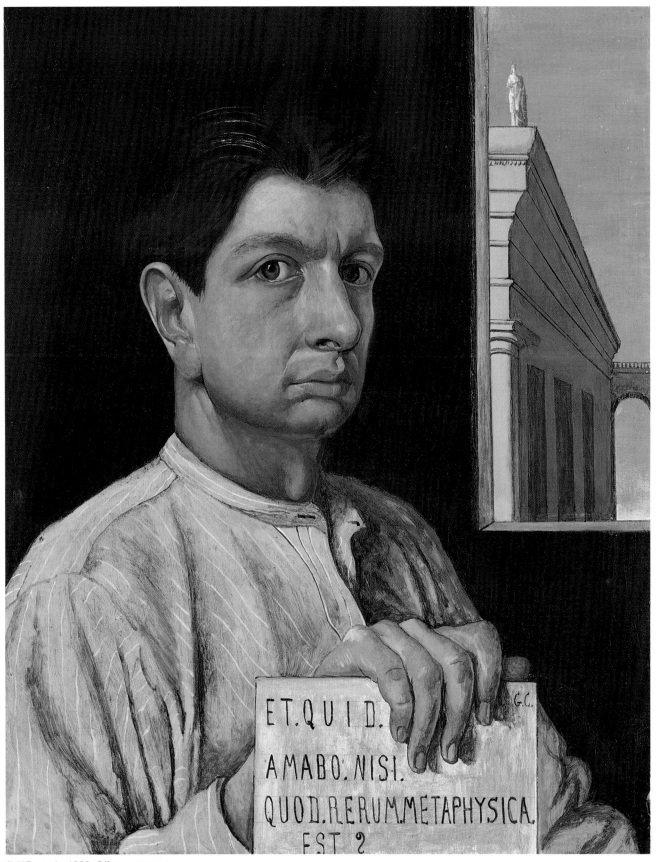

Self-Portrait, *1920. Oil on canvas,*
19½ × 15½″ (49.5 × 39.4 cm).
Staatsgalerie, Moderner Kunst, Munich.

De Chirico and Metaphysical Painting

Regarded by many as the greatest Italian painter of our time, Giorgio de Chirico was a forerunner of several important modern art movements. He founded the Metaphysical school of painting; he signed the Dadaist Manifesto; he exhibited with the Surrealists in their first show in Paris—and yet ultimately de Chirico stood on his own. An artist with a singular vision that defied the artistic circles of his time, he was, without a doubt, a most elusive figure in the art world. The direction of his work at times coincided with the dominant trends of the contemporary art scene. At others, however, it veered away in an anti-Modernist and even polemic manner. The artist's extensive oeuvre—he lived until he was ninety—is often contradictory. Yet he was a crucial player in the formative years of modern art.

The Revelation

Like many of his contemporaries, de Chirico sought a departure from the traditional way of looking at the object world through painting. "To denude art of everything that is common and generally accepted," he once wrote of the role of painting; ". . . to liberate it once and for all from anthropomorphism. " This rejection of painting as a system of representation led him in the early years of his career in Munich to Symbolism, but it took its definitive form some time later in Italy. As thoughtful a writer as he was a painter, de Chirico later described this formative moment: It was a sunny autumn afternoon in 1910, in Florence's Piazza Santa Croce. The painter was recovering from a debilitating intestinal illness: "The whole world around me, including the marble of the buildings and fountains, seemed to me to be convalescing." In the square was a sculpture of the great Italian poet Dante; "the autumn sun, strong and warm, brightened the statue and the facade of the church. I then had the strange impression of looking at those things for the first time." The setting was familiar—an Italian square—but by seeing it through his altered state of mind at the time, he had transformed the familiar.

This revelation produced *The Enigma of an Autumn Afternoon* (private collection), exhibited in Paris in 1912, and a series of deserted, frozen cityscapes, populated with mysterious arcades in perspective, elongated shadows, mannequins, towers, and chimneys. All appeared transfigured and vaguely menacing, as if the objects and places had been divested of their comfortable familiarity to acquire a strange and spectral life. With the juxtaposition of those plazas and arcades, Louis Aragon astutely noted, "it would be possible to map out the plan of an entire city." De Chirico called this moment of revelation—and the work derived from it—an enigma. The significance of the event was to be explored over and over again during the following years in his "Metaphysical" paintings.

Surrealism

It seems it was the poet Guillaume Apollinaire who first described these paintings as "Metaphysical," a title which would name a group of artists

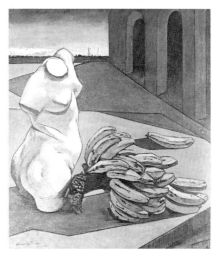

The Uncertainty of the Poet, *1913. Oil on canvas, 41½ × 37" (105.4 × 94 cm). The Trustees of the Tate Gallery, London. A work representative of the painter's concerns during his Metaphysical period.*

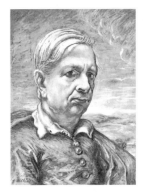

Self-Portrait, *1948. Oil on canvas, 15¾ × 11¾" (40 × 30 cm). Private collection. De Chirico's fascination with his own image is demonstrated by the numerous works in which he portrayed himself, often quite theatrically in costume.*

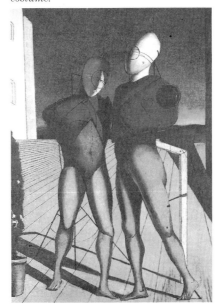

The Duo *(detail), 1915. Oil on canvas, 32¼ × 23¼" (81.9 × 59 cm). The Museum of Modern Art, New York. James Thrall Soby Bequest.*

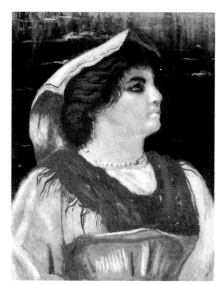

The Peasant Woman, *1925. Oil on canvas, 33 × 26¾″ (84 × 68 cm). Private collection, Rome. After 1919, de Chirico adopted a new language of academic realism.*

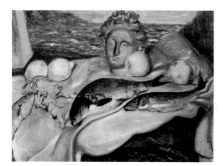

Still Life, *1929. Oil on canvas, 28¾ × 39¾″ (73 × 101 cm). Galleria Nazionale d'Arte Moderna e Contemporanea, Rome. A renewed interest in the old masters was accompanied by great attention to the artist's craft.*

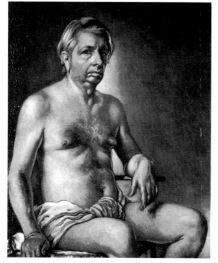

Self-Portrait in the Nude, *1942 or 1945. Oil on canvas, 23⅞ × 19⅝″ (60.5 × 50 cm). Galleria Nazionale d'Arte Moderna e Contemporanea, Rome. Gift of Isabella Pakszwer de Chirico.*

formed around the art journal *Valori Plastici* in 1918. Their works attracted a veritable cult following among the Surrealists, particularly surrounding de Chirico, whose fantasy world so inspired them. Already an established painter by then, de Chirico joined Pablo Picasso in supporting the fledgling group by taking part in their first group exhibition in 1925. The relationship of the Surrealists and de Chirico was very intense between 1924 and 1928, although their basic approaches were notably different. This, in fact, was more of a determining factor in their eventual split than the general incomprehension displayed toward de Chirico's new direction during the 1920s. De Chirico never painted dreams nor did he exactly attempt to express the world of the unconscious in his paintings. It is certain that he aimed to get closer "to the dreams and openness of the spirits of children," in order to strip objects of their burden of meaning. It is often said that de Chirico painted phantom cities, when what he really did was reduce the spaces and objects that he painted to the condition of phantoms. It is this detachment that converts his images into disturbing, even sinister omens: breaking up the relationship of meaning among objects.

Discovering Classical Painting

De Chirico received the second revelation of his career in 1919, while standing before a painting by Titian in the Borghese Galleria in Rome. The artist related how he stopped seeing the work of art as "painted images," that is, how he learned to see the materiality of the painting itself, and how that universe of heroes, saints, and important figures from the past suddenly took on a life of its own, independent of the canvas.

All at once the legacy of the great master painters became a phantasm, like the mannequins and objects that inhabited the ghostly cityscapes of his Metaphysical period. He translated this discovery into paintings executed in the classical style of Raphael, Antoine Watteau, and Eugène Delacroix; but de Chirico also explored it through the reworking—and even exact reproduction—of his own Metaphysical paintings and, finally, through a merging both of academic techniques with modern themes and modern techniques with academic themes.

A Metaphysical Continuum

This change of direction in de Chirico's painting was related, in part, to a return to the classical order led by such painters as André Derain and Pablo Picasso in the 1920s. For de Chirico, however, it was a much more complex operation that ultimately demonstrated a coherence underlying all of his works. The Surrealists and the vanguard establishment did not understand it as such, condemning his rediscovery of classicism as reactionary. The reverberations of that attack have still not entirely died down, despite revisionist theories of highly regarded Post-Modernists in the last ten years. What is certain is that the mythological world of the classical painters was as valuable to de Chirico's art as the disturbing fantasies of the second decade of this century. De Chirico always aspired to an art form dissociated from representational logic, out there where "neither the murmur of the streams, the song of birds, nor the whispers of the leaves can distract you." Throughout his long career the painter spoke with different voices. He entered and left different spheres with freedom; but in some sense, the Metaphysical realm was the domain of all of his paintings.

Giorgio de Chirico / 1888–1978

Although his parents were Italian, Giorgio de Chirico was born in the Greek town of Volos in 1888. His early years were divided between Volos and Athens. His younger brother, Andrea, who also became an important painter known by the pseudonym Alberto Savinio, was born in Athens in 1891. The de Chiricos were a cultured family. Giorgio's father, a railroad engineer of Sicilian descent and his mother, from a noble Genoan family, never opposed the artistic inclinations of their sons, but instead encouraged them.

The Shadow of His Father

Giorgio showed a preference early on for painting; he had private drawing lessons and then attended art classes at the Polytechnic Institute of Athens in 1899. Four years later he began working in the studio of the Greek portraitist Jacobidis, where he probably executed his first paintings, although no record of them remains. His familiarity with the ruins of ancient Greece played a considerable role in the configuration of his pictorial universe—as did the death of his father in 1905, when the artist was only sixteen. Many critics have linked the detachment and anguish in his pictorial spaces to his father's death and de Chirico himself later wrote in his *Memoirs:* "I struggle in vain against the man with enormously kind yet suspicious eyes, who frees himself sweetly from my embrace, smiling, hardly lifting his arms. My father appeared thus in my dreams. . . . "

De Chirico had an extraordinarily long career; from his early years in Athens at the Polytechnic Institute at the beginning of this century until well into the 1970s, he never stopped painting.

A Background in Philosophy

After his father's death, Giorgio, his brother, Andrea, and their mother visited Italy. They stayed briefly in Florence, Venice, and Milan, and then moved to Germany to continue the boys' artistic training. The family remained in Munich for four years, soaking up the intense artistic atmosphere of one of the principal centers of European culture. The Swiss Romantic painter Arnold Böcklin greatly inspired the young artist and his presence can clearly be noted in de Chirico's early works. Although the Munich art scene provided much fodder for a young artist, de Chirico was most affected by the literature of the times, primarily the German philosophers such as Arthur Schopenhauer and, above all, Friedrich Nietzsche. This distinctive grounding was markedly different from that received by most other young French and Italian artists of the period, whose lessons came largely from the poetic traditions of Romanticism—Charles Baudelaire, Arthur Rimbaud, and Stéphane Mallarmé. This difference helps to explain the singularity of de Chirico's work, which his contemporaries did not always understand. It also provides a clue to his method of painting, which was first intellectual and then pictorial.

De Chirico returned briefly to Italy: Milan, Florence, and Turin—where Nietzsche had lived. Although only a year, this short tour forever left its imprint on his work. It was here that his Metaphysical painting took form after a "revelation" in Florence. The piazzas of these cities, Renaissance facades, and the light and shadows of an Italian autumn marked the end of his Romantic Böcklin-influenced body of work.

In the summer of 1911 de Chirico and his mother joined Andrea in

Portrait of Isa in a Black Dress, 1935. Oil on canvas, 39⅜ × 31¾″ (100 × 80.5 cm). Galleria Nazionale d'Arte Moderna e Contemporanea, Rome. Gift of Isabella Pakszwer de Chirico. In Paris in 1930 de Chirico met the woman who would be his second wife, Isabella Pakszwer, a Russian immigrant.

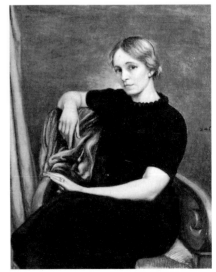

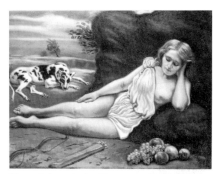

Diana Asleep in the Woods, *1933. Oil on canvas, 35⅝ × 46⅛" (90.5 × 117 cm). Galleria Nazionale d'Arte Moderna e Contemporanea, Rome. Gift of Isabella Pakszwer de Chirico. The language of academic painting is joined here with ancient Greek mythology.*

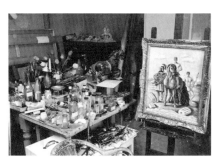

A detail of the artist's studio in Rome, showing a work in the classical style and small equestrian figures that probably served as models.

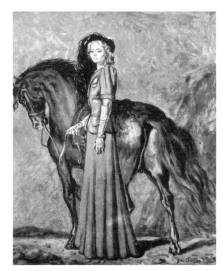

Amazon, *1934. Oil on canvas over cardboard, 23⅝ × 19⅝" (60 × 50 cm). Private collection, Rome.*

Paris. Shortly afterward Giorgio began painting his monolithic Tower and Enigma series, in which the disquieting and frozen scenery of his "Metaphysical" paintings was already present. These paintings attracted the interest of the poet and art critic Guillaume Apollinaire, the great champion of Cubism and modern art. Through his mediation, de Chirico exhibited paintings at the Salon d'Automne of 1912—the first public showing of his work. Through Apollinaire, he also met the art dealer Paul Guillaume, who later helped him and organized various exhibitions in Paris for him.

Founding a School of Painting

The two de Chirico brothers returned to Italy at the beginning of World War I to serve in the military. Giorgio was sent with the army to Ferrara which, together with Turin, became the source for the distinctively urban settings of his paintings. The Italian Futurist Carlo Carrà also arrived in Ferrara on military duty and the two met there in 1917. Together with de Chirico's brother and a few other Italian painters, among them Giorgio Morandi, de Chirico and Carrà founded the art journal *Valori Plastici* and began making their "pittura metafisica." *The Great Metaphysician* (plate 25) and *The Disquieting Muses* (plate 52; a 1925 copy of an earlier work) are typical of de Chirico's work during this time: the characteristic piazzas and arcades are populated with shadows, mannequins, and elements of classical origin.

In 1919 the artist experienced his classical "revelation" while standing in a museum before a painting by Titian. This prompted a reconsideration of academic painting from this point on.

It was his earlier, Metaphysical works, however, which were a beacon to the Surrealists in the 1920s. De Chirico moved to Paris in 1924, the year the group was founded, and for some time maintained close relations with André Breton and Louis Aragon. He participated in the first Surrealist exhibition in 1925 in Galerie Pierre and his work was rarely missing from issues of *La Révolution Surréaliste*. The Surrealists' devotion, however, was limited to de Chirico's work prior to 1919. This, together with evident ideological differences with the majority of the group, led to deteriorating relations after 1926. Breton launched an attack on de Chirico, accusing him of substituting "artificial respiration of the painting for the inspiration of dreams," and de Chirico retaliated, branding the Surrealists "cretinous and hostile people." The indebtedness of Max Ernst, René Magritte, or Salvador Dalí to his work is, nevertheless, unquestionable.

An Independent Artist

From the twenties onward, de Chirico combined incursions into the universe of Metaphysical paintings—at times literally reproducing previous paintings—with impeccable reworkings of the old masters such as Raphael (plate 27) and his own works. His condemnation by the Surrealists has led to much debate in critical circles; his later work has only recently been vindicated. Regardless of his critical reception, de Chirico experienced great commercial success after the thirties, thanks in part to his triumph in the United States, where he lived between 1935 and 1938. In 1944 he settled definitively in Rome with Isabella Pakszwer, his second wife, and continued painting until his death in 1978, freed from the artistic conventions that had once inspired him.

Plates

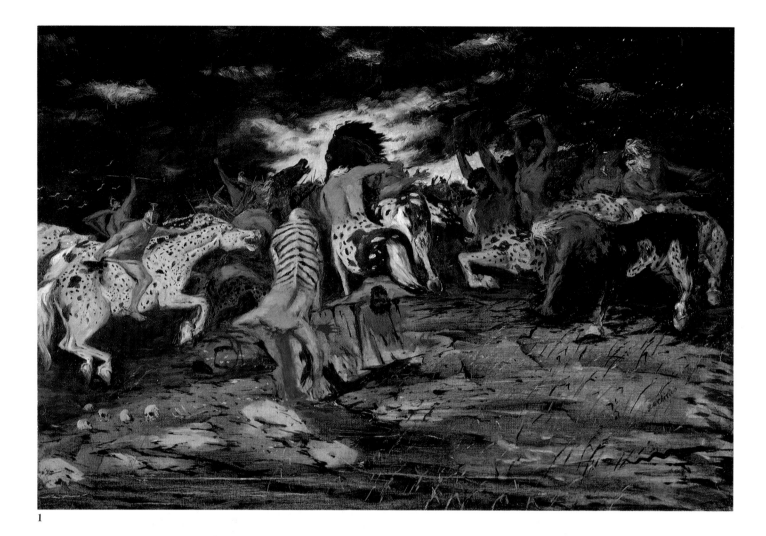

1

A Symbolist Training

Two cultural influences determined, around 1910, the first steps of Giorgio de Chirico as a painter: the years that he lived and studied in Munich (1906–1910), and his interest in the art and architecture of the Italian Renaissance upon his return to the land of his parents. Munich was the center of modern artistic experimentation during the first decade of this century. De Chirico's earliest paintings show signs of the Symbolist influence and the late Romanticism of Alfred Kubin and Arnold Böcklin, in keeping with his fascination for the philosophy of Friedrich Nietzsche. "Schopenhauer and Nietzsche," he would later write, "were the first to teach me the deep significance of the 'lack of meaning' of life, and how that meaninglessness can transform itself into art." This Symbolist proclivity, a prelude to the Metaphysical paintings, is reflected in the portraits that he made of friends and family as well as in the mythological scenes directly inspired by Böcklin.

1 The Battle of the Lapiths and the Centaurs, *1909. The mythological battle of the Centaurs and Lapiths has symbolized since antiquity the battle between barbarism and civilization. De Chirico extended this metaphor to the intellectual influences that inspired him during his early years in Munich.*

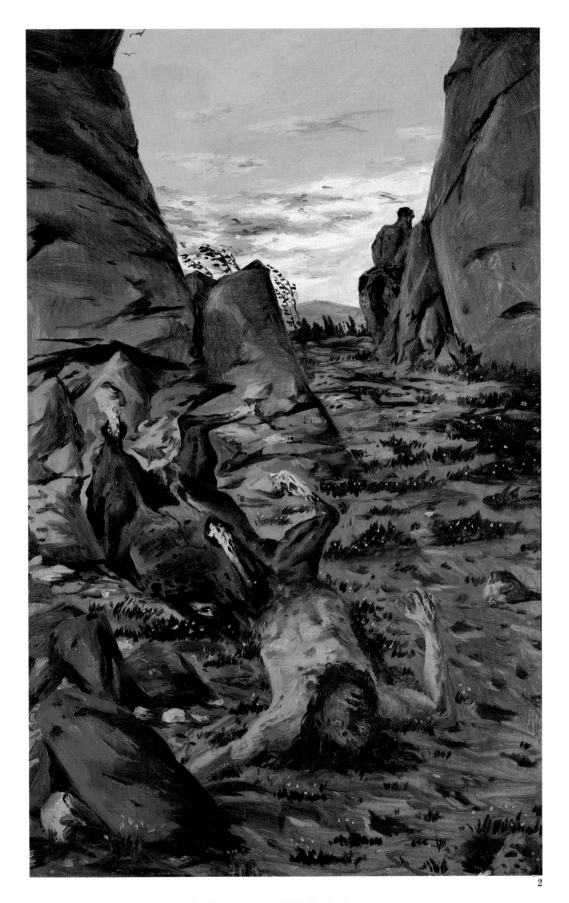

2

2 Dying Centaur, *1909. The thick, paint-
filled brush-strokes here contrast with the
smooth, flat planes that the artist used in
paintings after 1912. Following his
rediscovery of classical painting,
however, de Chirico returned in the
1920s to an approach similar to that
shown here.*

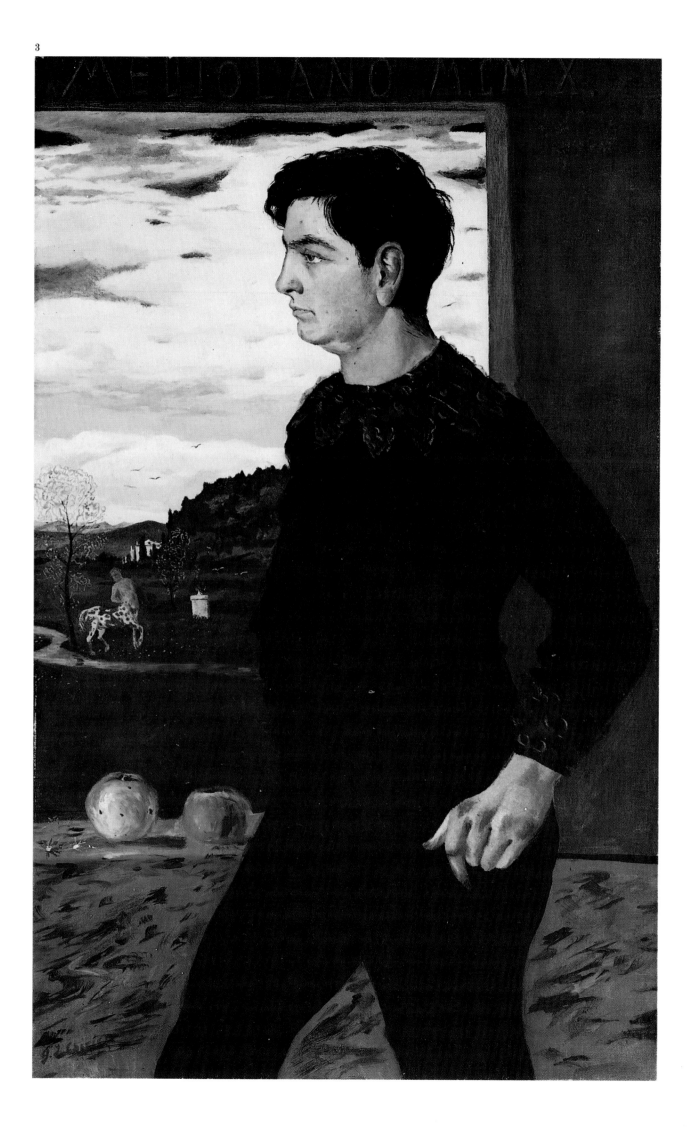

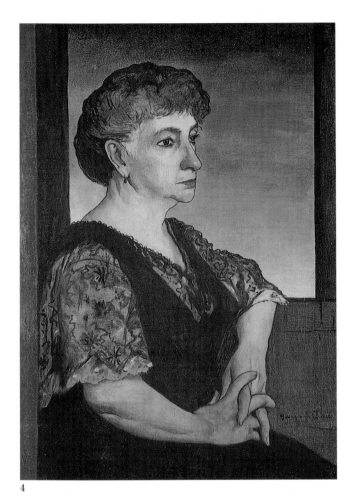

4

4, 5 Portrait of the Artist's Mother, *1911;* Portrait of Mrs. Gartzen, *1913. The placement of a figure next to a parapet or stone windowsill, beyond which can be glimpsed the horizon, is a compositional technique borrowed from Italian Renaissance art. The uncertain twilight creates an atmosphere of strange melancholy that prefigures de Chirico's Metaphysical cityscapes.*

5

3 Portrait of Andrea de Chirico (Alberto Savinio), *1910. Although he initially studied music, de Chirico's younger brother, Andrea, also made his name as a painter. He adopted the pseudonym Alberto Savinio in 1914, perhaps to avoid the confusion of two de Chirico painters. Giorgio probably painted this Symbolist portrait in Milan, upon his return from Munich in 1910, judging from the inscription on the lintel over the window.*

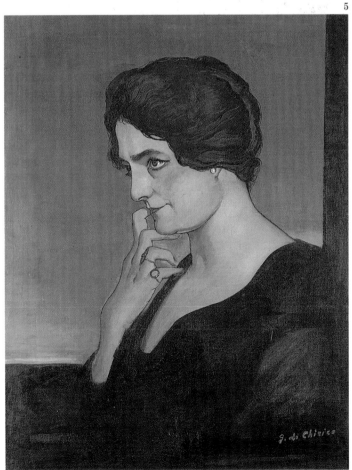

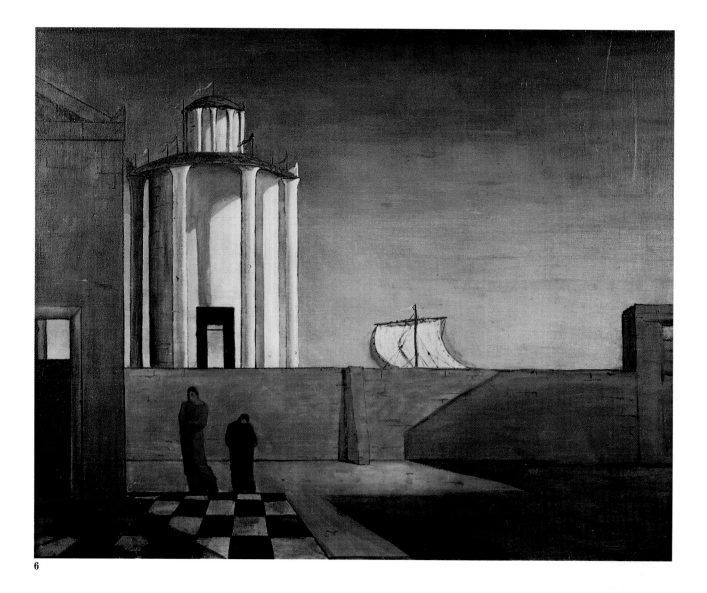

6

The Metaphysical Paintings

The term "metaphysical" represented to de Chirico a search for the essential meaning hidden behind the surface of objects. He believed that objects acquire various meanings when imbued with the memory of their viewer. If that which de Chirico called the "chain of memories" is broken, the objects acquire a new and disquieting guise, "a ghostly and metaphysical aspect that only a few individuals can see in moments of clairvoyance and metaphysical abstraction." The architecture of Turin and Ferrara, with their solemn porticoed streets and wide piazzas, was for de Chirico the most appropriate setting for these images—locomotive trains, statues, silhouettes—which are frozen and outside the flow of time. The depth of perspective in these vistas is often fictitious, and the canvases often contain contradictions that subtly underscore the sensation of estrangement and anguish that fascinated the Surrealists. De Chirico confined himself to this repertoire between about 1912 and 1919. Throughout his career he returned intermittently to these Metaphysical themes which, while they identify him as a painter for art historians, still do not exhaust the range of his oeuvre.

6 The Enigma of the Arrival and the Afternoon, *1912. The idea of the painting as an enigma, impossible to resolve, is presented in the title of many of the first Metaphysical paintings. This same approach was adopted fifteen years later by Surrealist painters, such as Salvador Dalí.*

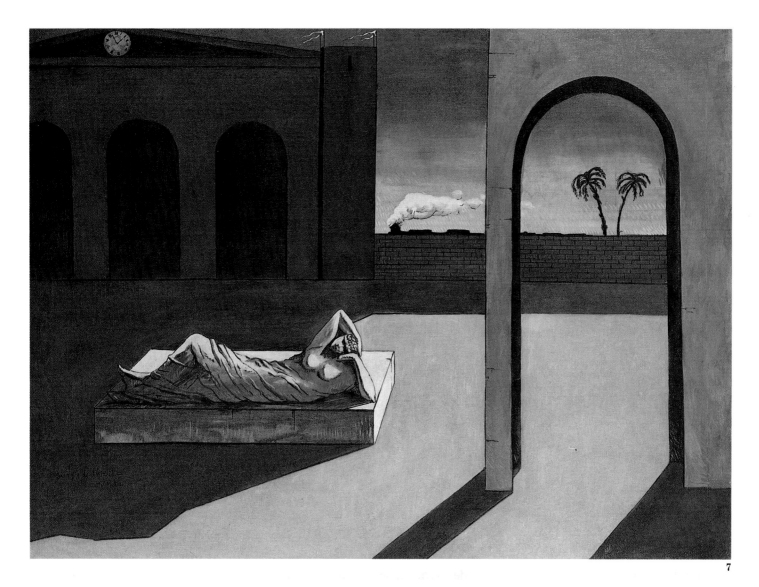

7

7 The Soothsayer's Recompense, *1913. The shafts of late-afternoon light imbue the ancient statue with a strange life of its own. In contrast, the train seems lifeless, eternally frozen, as if it might never reach its destination, the nearby station.*

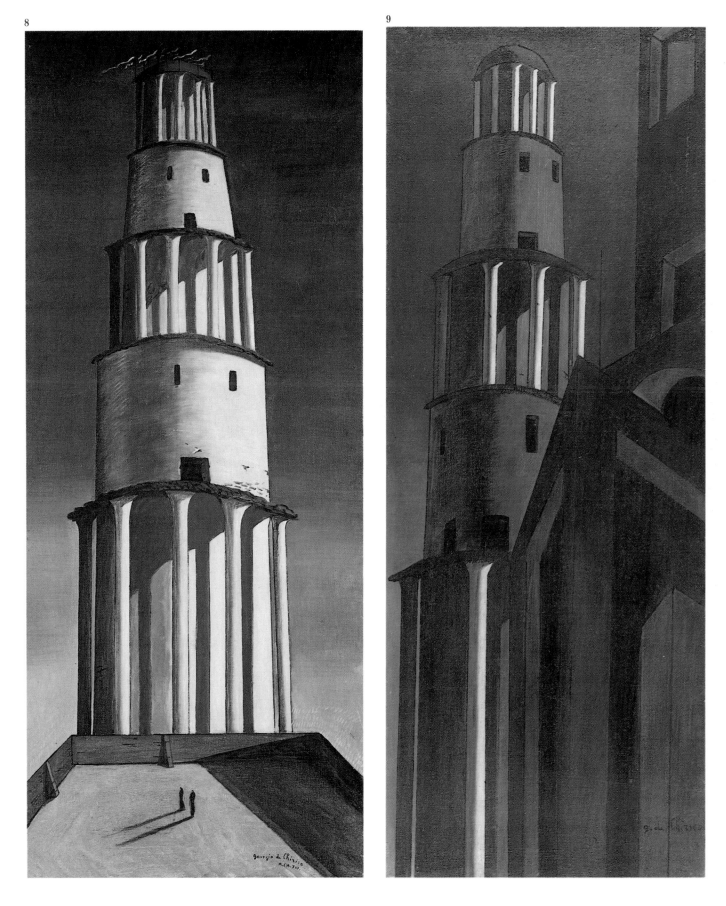

8, 9 The Great Tower, *1913;* The Tower, *1913. Towers, circular or square, and composed of wedding-cake-like layers of varying columns are repeated as a central theme in several paintings completed during the artist's first stay in Paris.*

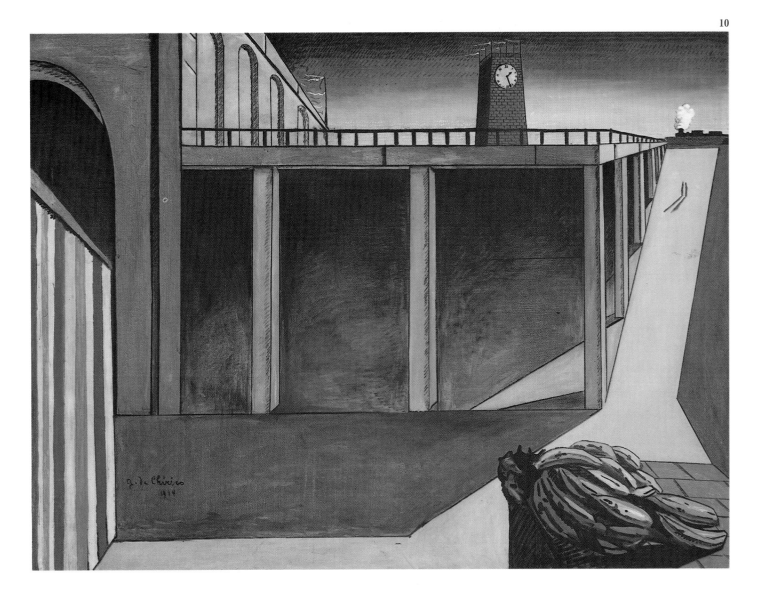

10 Gare Montparnasse (The Melancholy of Departure), *1914. The disturbing and puzzling elements—perhaps the principal attributes of Metaphysics according to de Chirico—are achieved by subtle and deliberate incoherencies in the representation; thus, the frozen movement of the train is contrasted with the flags flying in a nonexistent wind, or the impossible ascending perspective of the yellow ramp. The bunch of bananas, which is repeated in other paintings of the same period, introduces an exotic element— uncontaminated nature amidst a ghostly cityscape.*

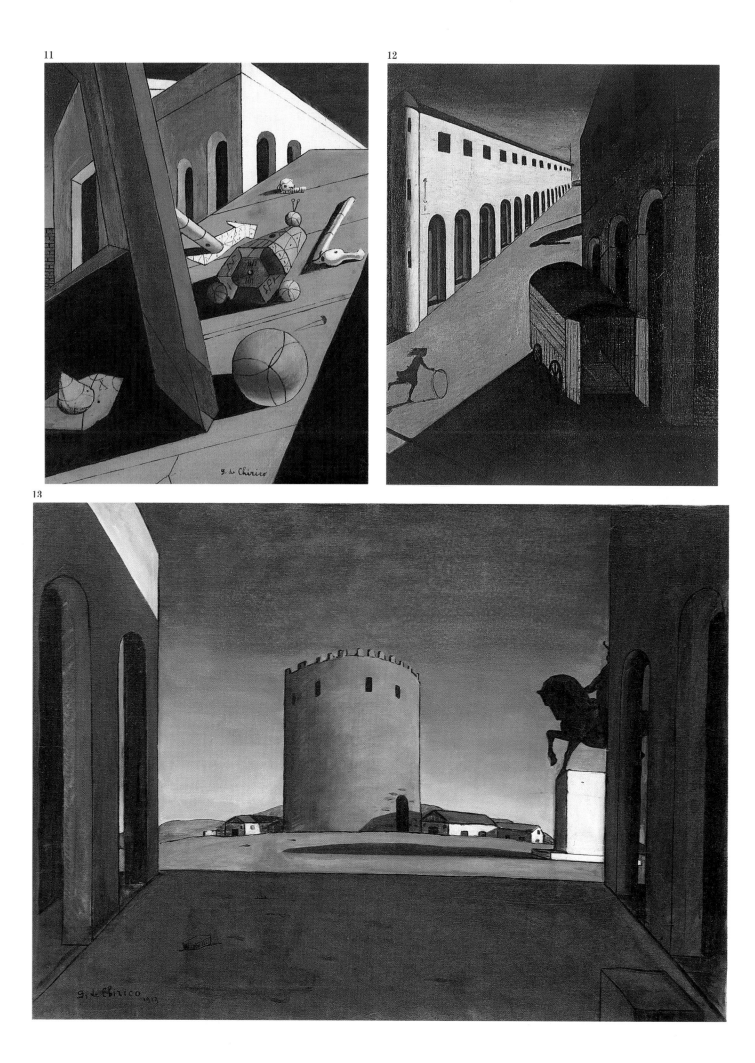

18

11 The Evil Genius of a King, *1914–15. The floor tilts upward, as if shaken by an earthquake; it forms a ramp upon which the objects slide downward, stopped only by their own transverse shadows.*

12 The Mystery and Melancholy of a Street, *1914. "In Turin, everything is an apparition, all the nostalgia for the infinite is revealed to us behind the geometric precision of the piazza," wrote Nietzsche during his travels through the Italian city. De Chirico, an early reader of the German philosopher, seems to illustrate his words with scenes like this. The elongated perspective casts a melancholy pall over the painting.*

13 The Red Tower, *1913. Apollinaire, who had acquired this painting, arranged for it to be exhibited in Paris in the Salon d'Automne. The equestrian image and the crenellated tower are reminiscent of Dalí's Knight of Death, 1935, an example of de Chirico's profound influence on the Surrealists.*

14 The Enigma of Fatality, *1914. The skewed scale between the red glove and the buildings introduces the idea of the all-powerful "hand of fate" implicit in the title. The triangular format, with the industrial chimney serving as the central axis, accentuates the constricted sense of space.*

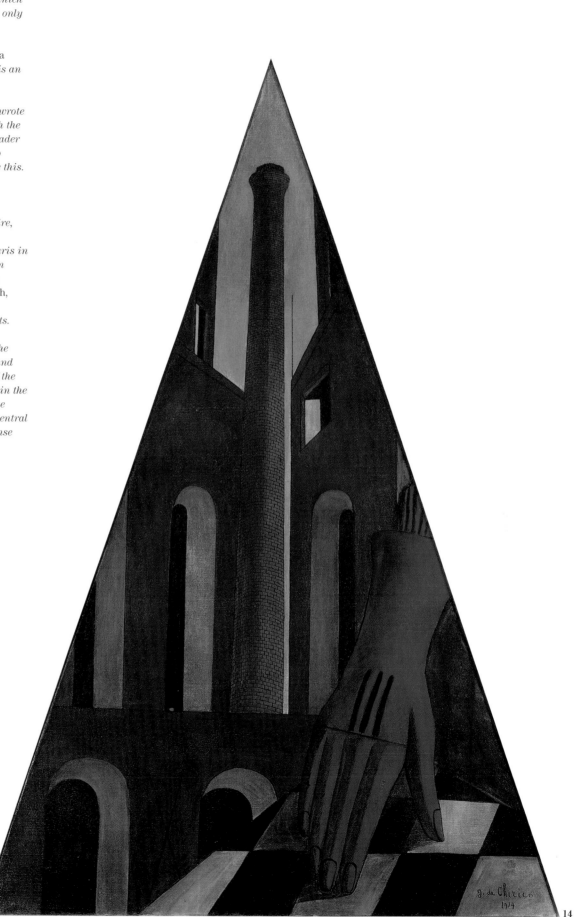

14

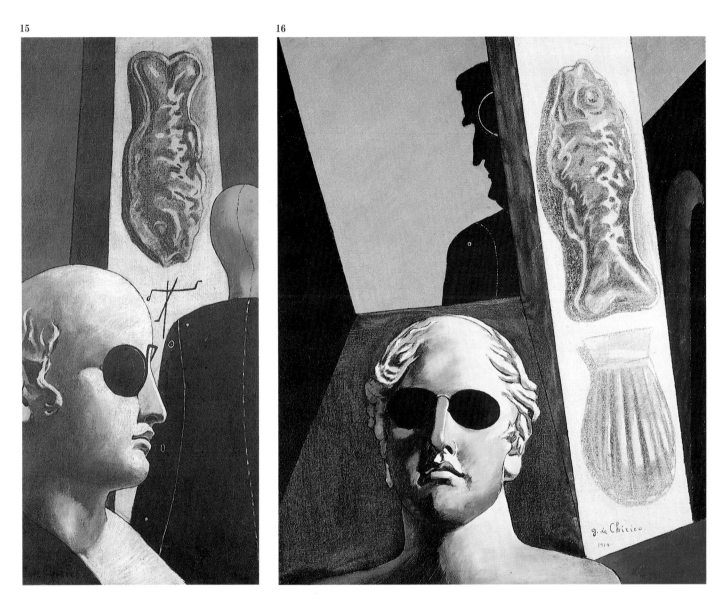

15, 16 The Dream of the Poet, *1914; Portrait of Guillaume Apollinaire, 1914. These two paintings are in homage to the poet Apollinaire, great champion of the de Chirico brothers. The dark glasses over his eyes allude to the mythic blindness of the prophet. "What I hear," wrote de Chirico, " has no value, only what I see is alive; and when I close my eyes, my vision is even more powerful."*

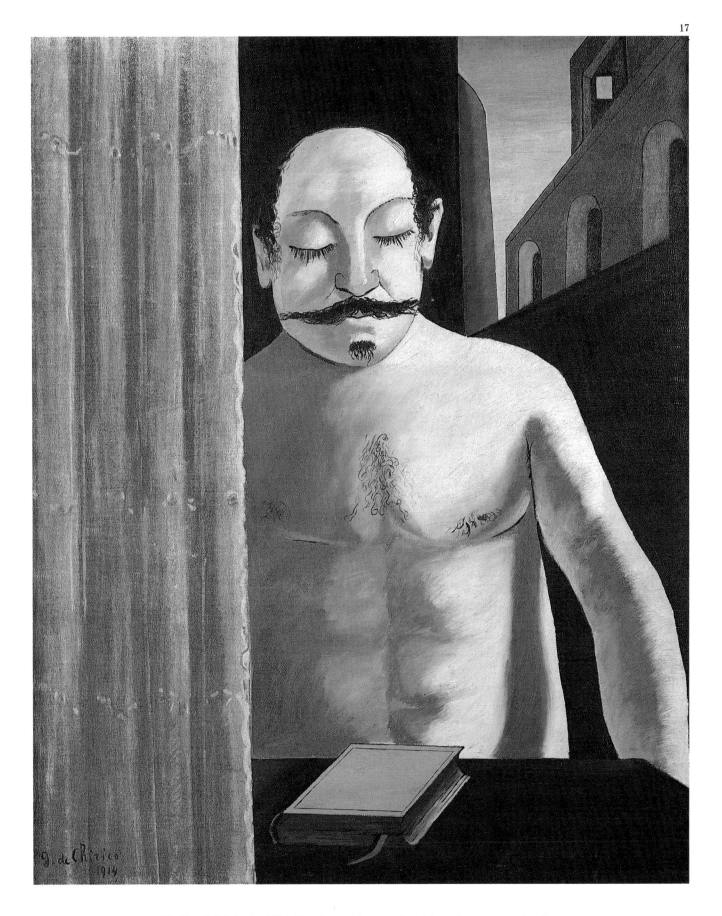

17 The Child's Brain, *1914. Freudian critics seized on this work as an example of an
infantile fantasy, stemming from de Chirico's close relationship with his mother;
others contend that it reflects a chronic melancholy occasioned by the loss of his father.
Again, the figure, whose ghostly status is evident by the white pallor that he shares
with the columns—and with the two busts in the Apollinaire portraits—is unseeing.*

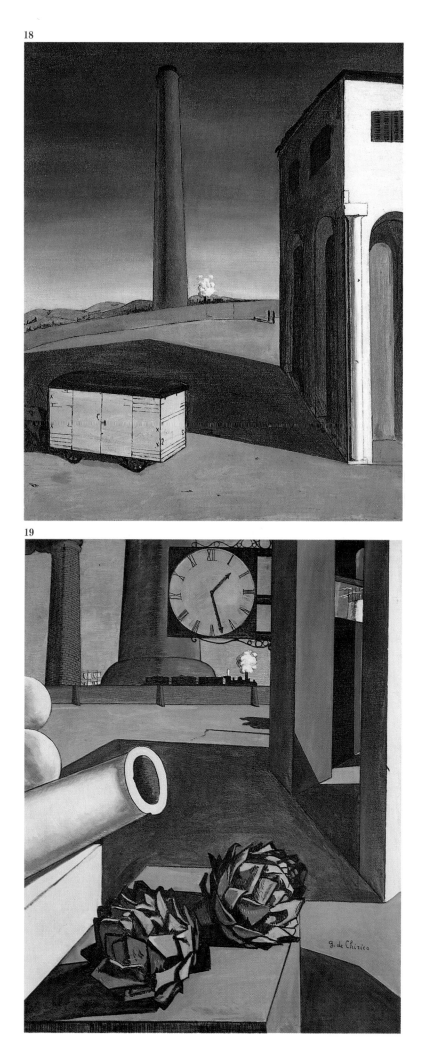

19

18, 19 The Anguish of Departure, *1913–14;* The Philosopher's Conquest, *1914. The objects of industrial civilization—the smokestack, the train—are a legacy of Futurism, which de Chirico reworked, reversing the Futurists' optimism about progress to a pessimism. Both paintings illustrate the idea of a journey or departure toward an unknown destination as a model of the Metaphysical enigma of fate. The artichokes, like the bananas in* Gare Montparnasse, *contrast nature and civilization. This theme was dealt with earlier still in* The Battle of the Lapiths and the Centaurs *(plate 1) from his Romantic Böcklin period.*

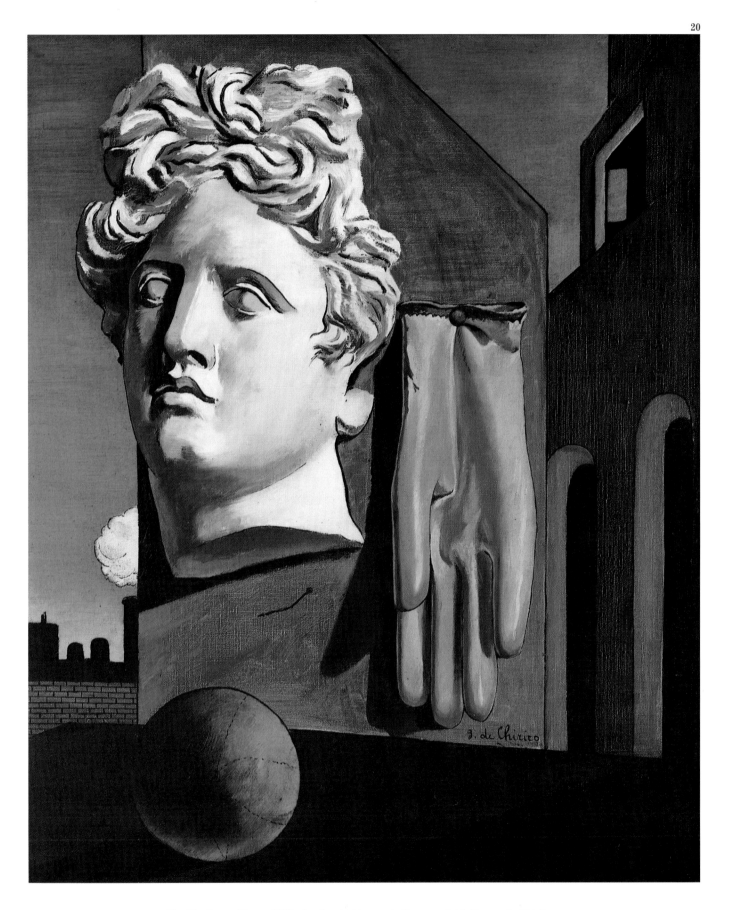

20 The Song of Love, *1914. Another testimony to the powerful influence de Chirico had on the Surrealists; René Magritte confessed that after seeing a reproduction of this painting in 1925, he came to his definitive style of painting. He later paid homage to the work in a 1929 painting entitled* Memory.

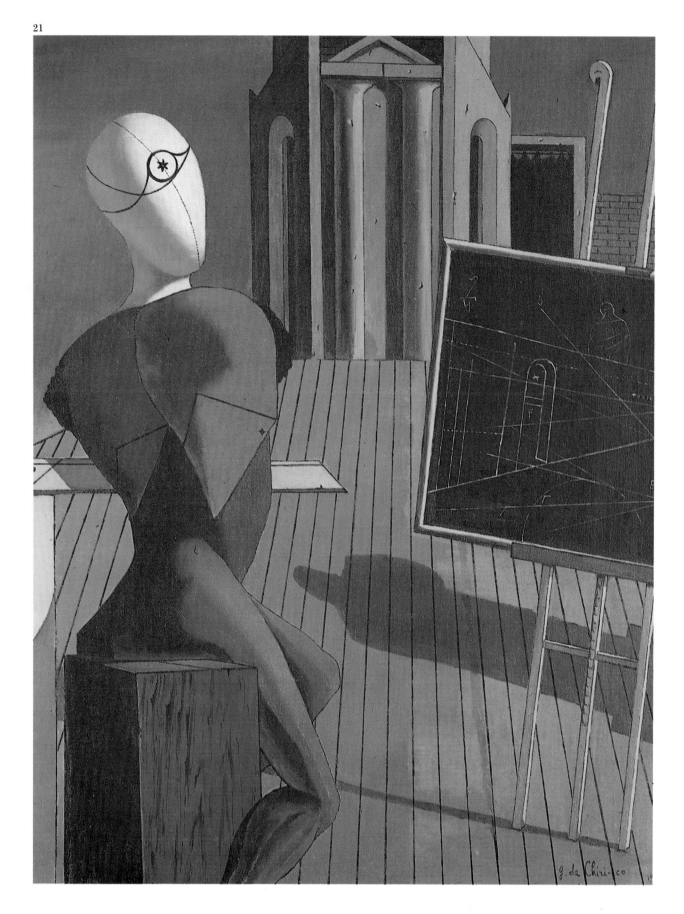

21 The Seer, *1915. Mannequins are the only inhabitants of these desolate*
Metaphysical paintings. Often appearing in Dadaist montages, they convey a sense of
estrangement and loss of identity.

22 The Melancholy of Departure, *1916. The journey, a theme explored by de Chirico*
in his trains and train station images, is transformed here into the tracings of an
itinerary on a mysterious map. The formal, almost Cubist language demonstrates the
artist's responsiveness to the trends of the artistic vanguard.

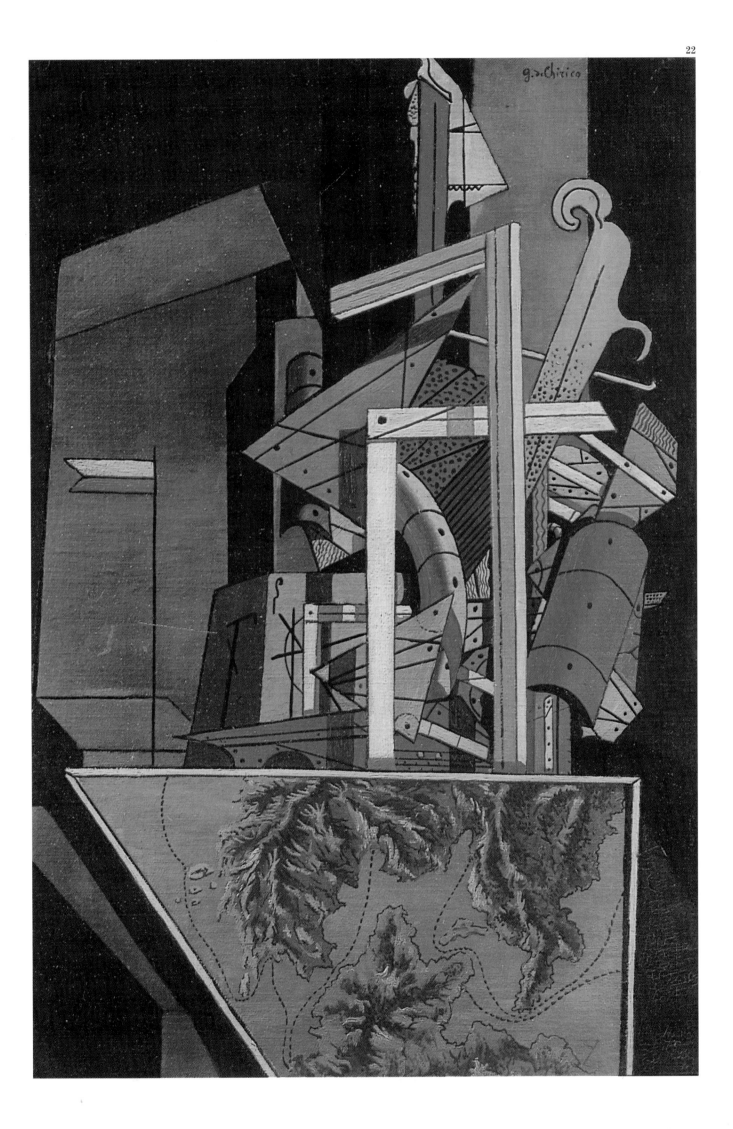

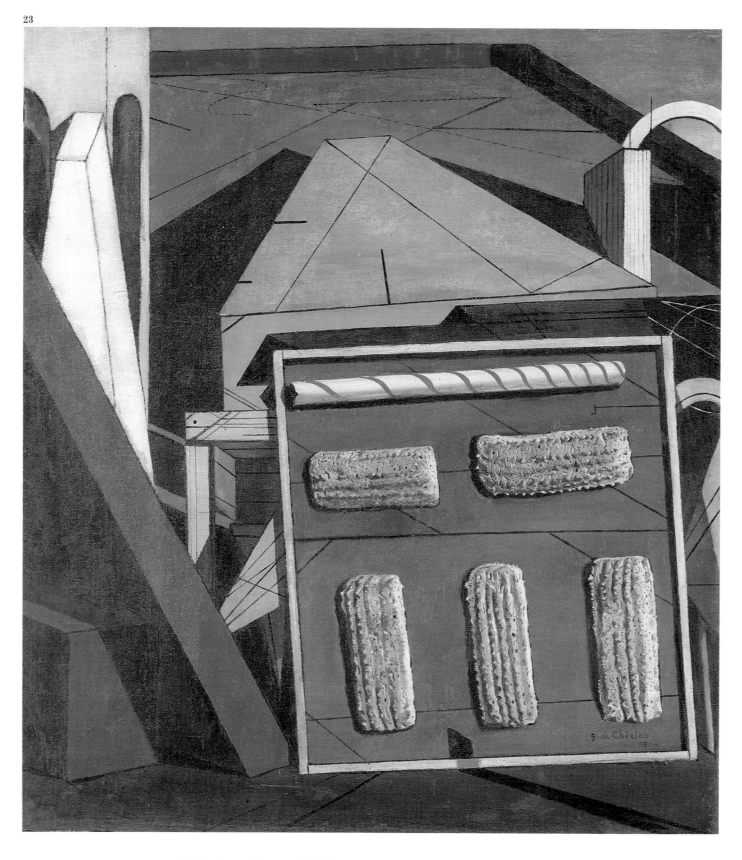

23 The Gentle Afternoon, *1916. De Chirico spent a good part of World War I in Ferrara, where he suffered a nervous breakdown and was committed to the military hospital. In this city, the world of his painting became more anguished; mannequins and masks were widely used in his iconography. Some of his most hermetic works date from this period, in which his juxtaposition of strange objects and planes of color accentuates even more the break-up in the chain of meaning that otherwise links objects together.*

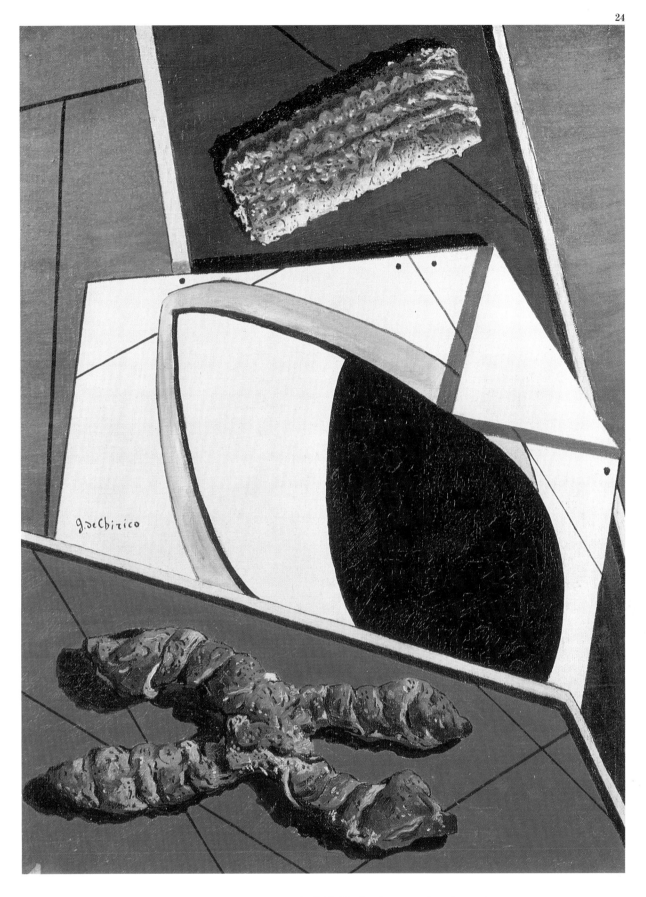

24 The Greetings of a Distant Friend, *1916. Similar in approach to the previous painting, de Chirico here juxtaposed different overlapping planes of color, demonstrating how far his complex language was capable of assimilating the technical contributions of contemporary artists like Matisse and Picasso.*

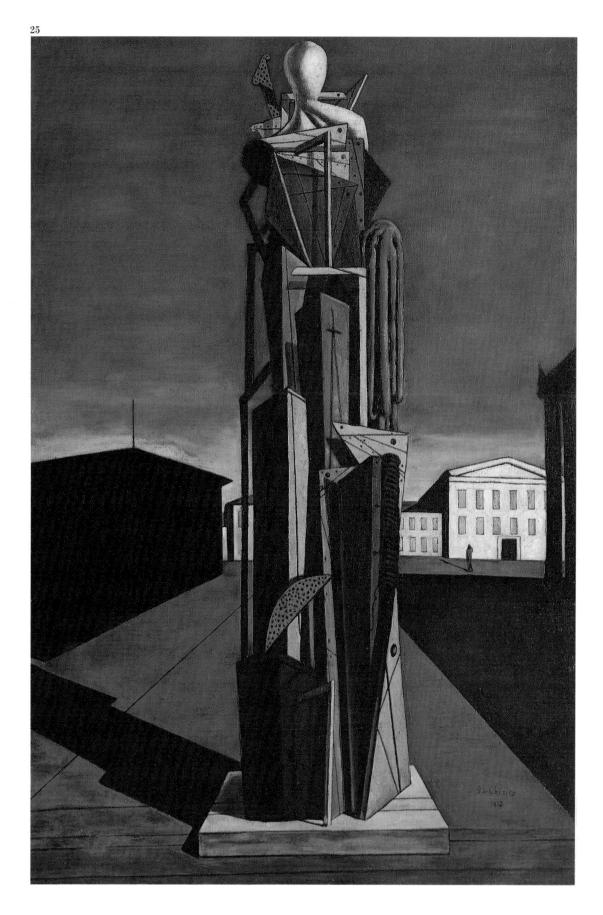

25 The Great Metaphysician, *1917. The background architecture replaces the somber archways of Turin in one of the most emblematic of the Ferrara paintings. The central figure, a mixture of mannequin, Cubist assemblage, and urban monument, observes a deliberately disproportionate sense of scale with respect to its surroundings.*

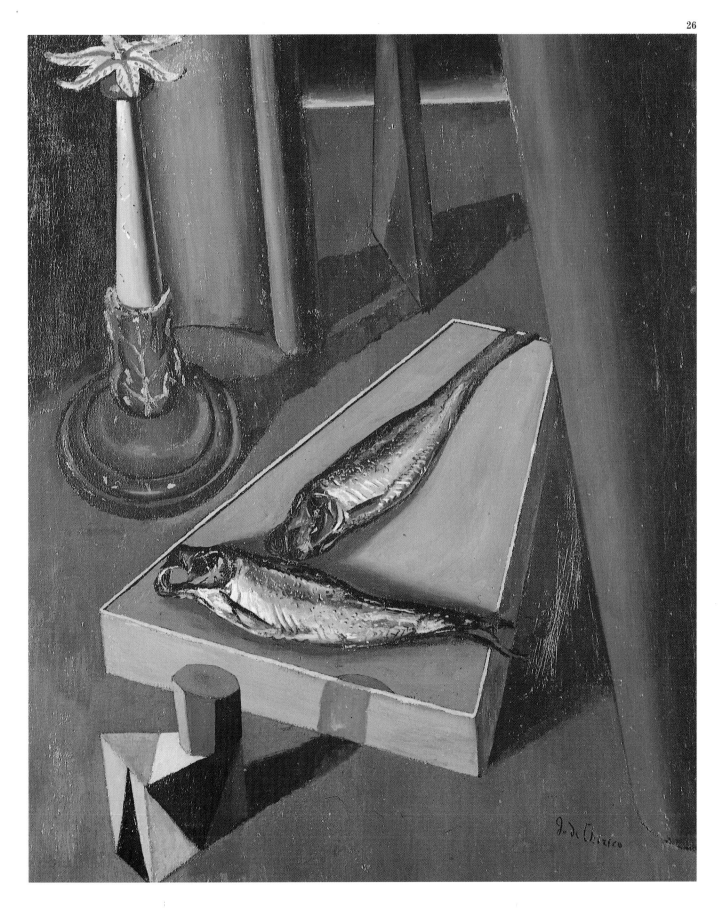

26 The Sacred Fish, *1919. The technique—a dense and dark use of paint—and a taste for volume announces the imminence of de Chirico's classical turn. The fish on a pedestal, seen from a distorted perspective, presents an unusual still life—or "silent nature" as the painter preferred to call it. The fish is a symbol of Christ, but was perhaps used here by de Chirico in a more ancient context, as an allusion to the divinatory powers once attributed to readers of fish entrails.*

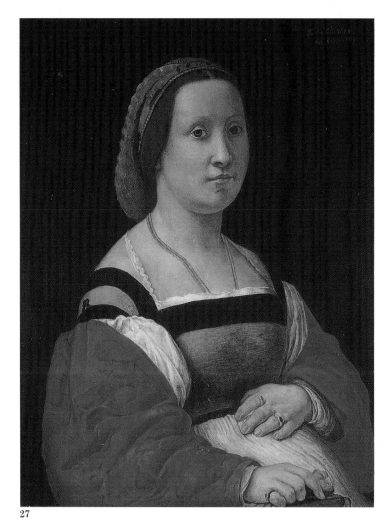

27

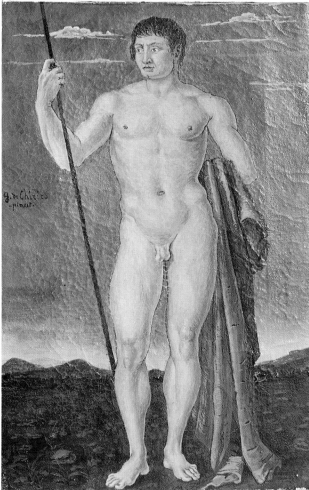

28

A Return to Classicism

After the end of World War I de Chirico abandoned Metaphysical painting for a time to enter completely into the world of the old master painters. Although the results of this new body of work were quite different from his "pittura metafisica," de Chirico's modus operandi was basically the same: he identified all the familiar elements found in the master paintings, but transformed them with his own peculiar vision. He combined a deceptive fidelity to the original models with elements from his Metaphysical repertoire, taking certain liberties with the treatment of the language and themes of the old paintings. This return to an academic order resulted in the marginalizing of de Chirico by those who had once most applauded his previous work—the Surrealists. He had not yet gone to the extremes of the direct reworking of old master paintings that he later undertook.

27 The Pregnant Woman (after Raphael), *1920. This is a reworking of a classical painting with only a slightly softer approach than the original.*

28, 29 Saint George, *1920;* Lucretia, *1922. Both portraits are based on fifteenth-century Italian paintings, perhaps by Antonio del Pollaiuolo or Andrea Mantegna. Nevertheless, the chromatic range, especially in* Lucretia, *is not so different from that used in the phantom cities of the Metaphysical paintings. The glimpse of the horizon and the sky striated with clouds are reminiscent of de Chirico's earliest portraits.*

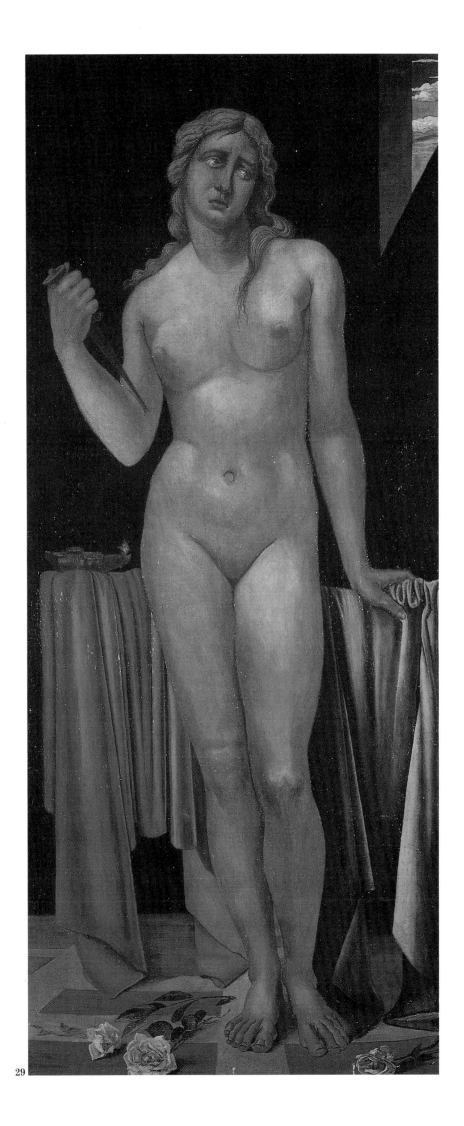

29

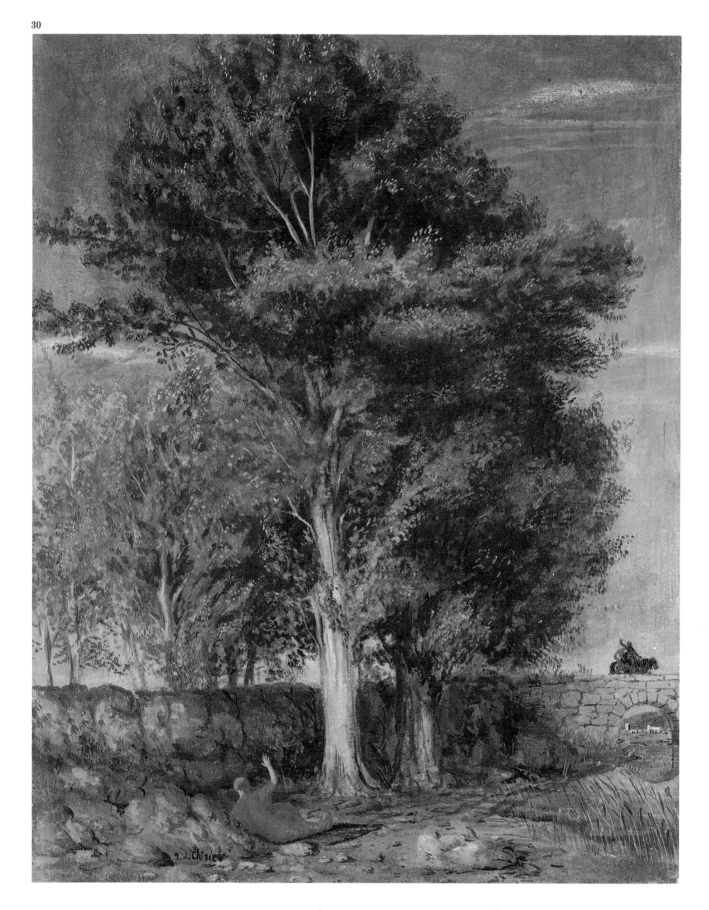

30 The Poet's Farewells (Tibullus and Messala), *1923. Beneath the bucolic composition of an eighteenth-century landscape lies de Chirico's recurring obsession with "departure." Here the distant figure on horseback recalls the steaming, frozen locomotives of ten years earlier.*

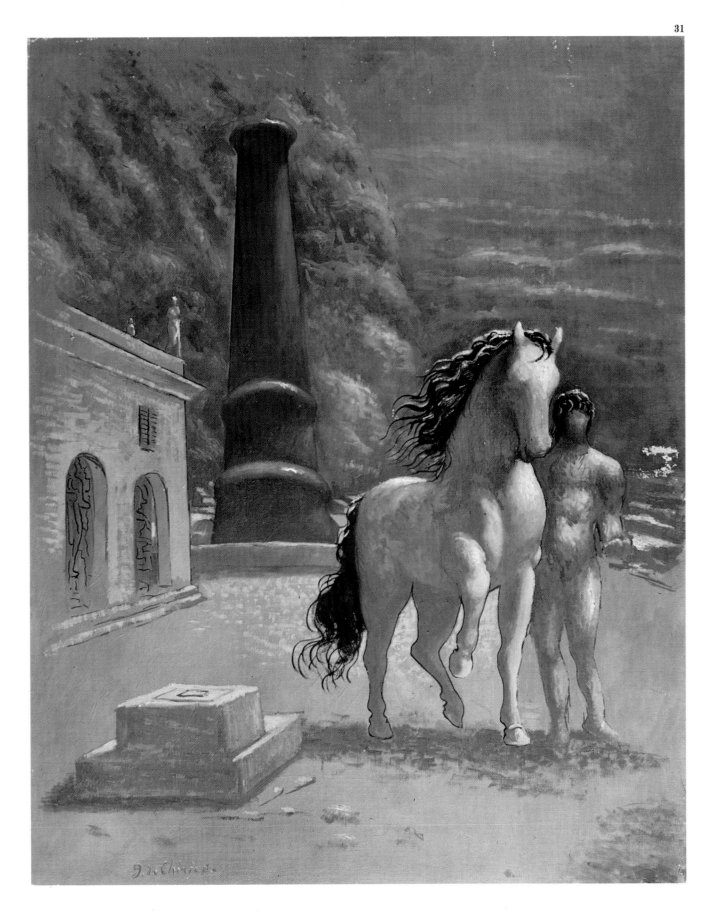

31 The Shores of Thessaly, *1926. One of the clearest examples of Metaphysical
iconography draped in classicism. Despite its Roman air, the building on the left is a
copy of Turin's arcades; the chimney's association is obvious. Even the empty pedestal,
as if the man and horse had come to life and abandoned it, corresponds to the same
sort of rhetorical game.*

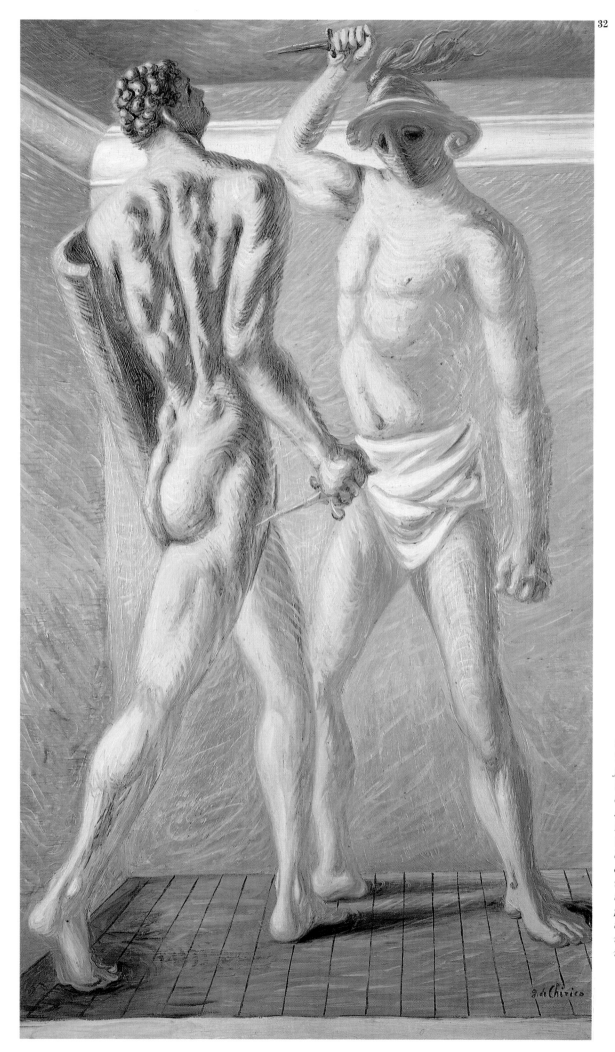

32 Gladiators, *1928. The position of the figures and the painting technique seem to be a commentary in the sixteenth-century Italian Mannerist mode. The change of scale between the two combatants is nevertheless a tactic taken from Metaphysical painting. The mask on the gladiator on the right also recalls the mannequins of Ferrara.*

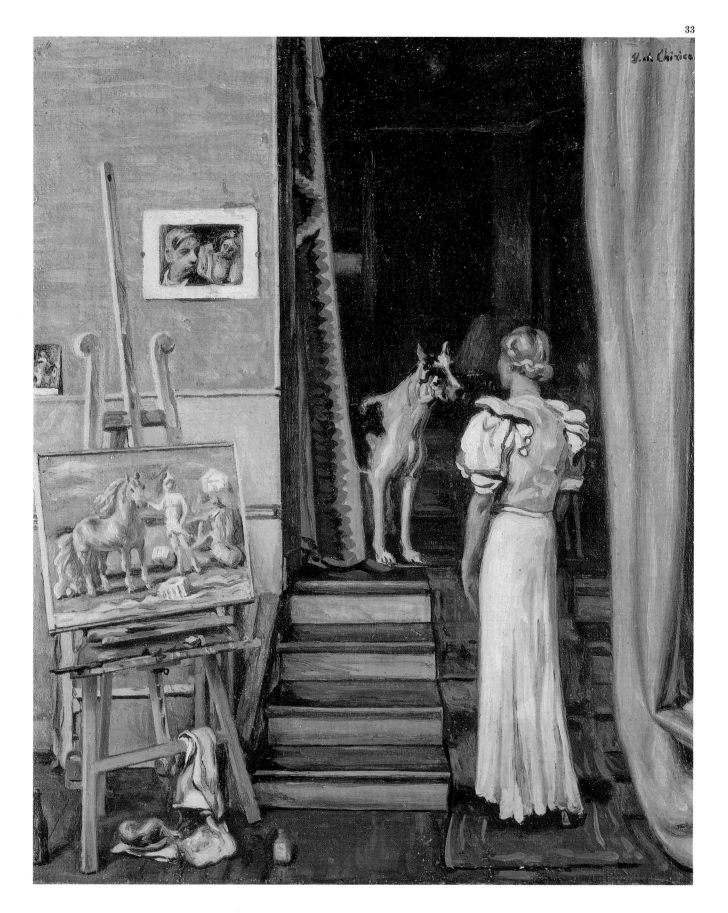

33 The Master's Studio in Paris, *c. 1933–34. The reference to Velázquez's* Las Meninas, *1656, is evident here: both canvases play with the idea of a painting within a painting; both also contain a dog, a curtain, and a doorway in a darkened background. The figure seen from the back is Isabella, de Chirico's second wife.*

34

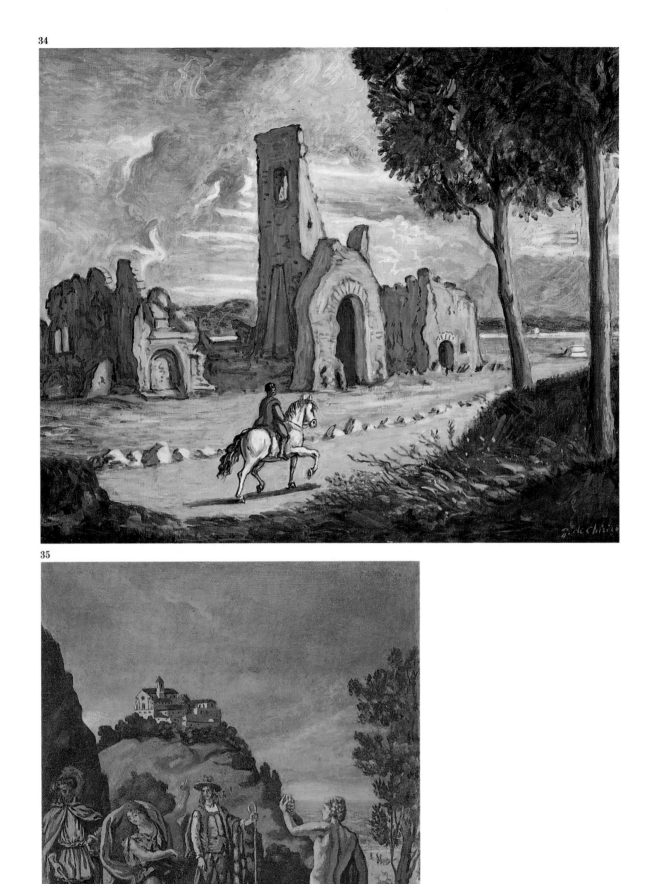

35

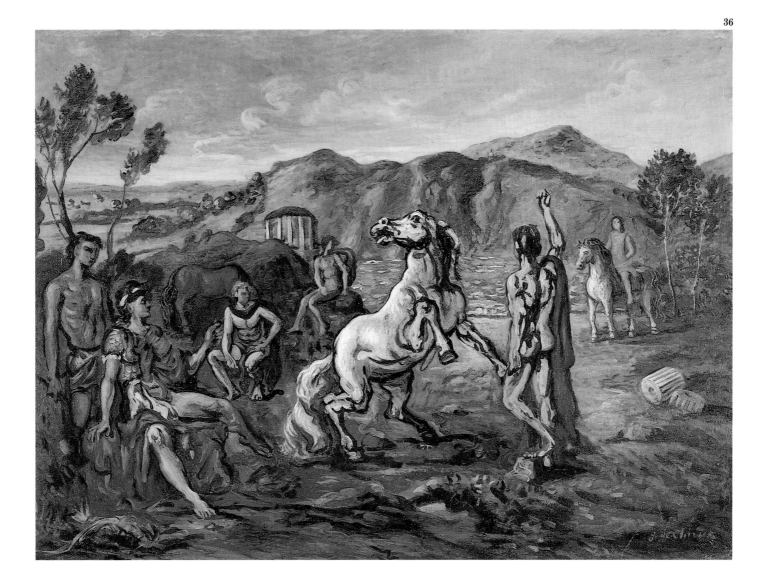

34 The Via Appia, *c. 1954. The forlorn backdrop of ruins, taken from the poetics of eighteenth-century landscape painters like Hubert Robert, is once again associated here with the theme of the journey.*

35, 36 Rural Scene with Landscape, *c. 1960;* Horsemen with Horses by the Sea, *c. 1960. While these two Arcadian landscapes are strictly eighteenth century in composition, the technique, which is slightly nervous and heavily outlined, particularly in the second painting, reveals a contemporary touch.*

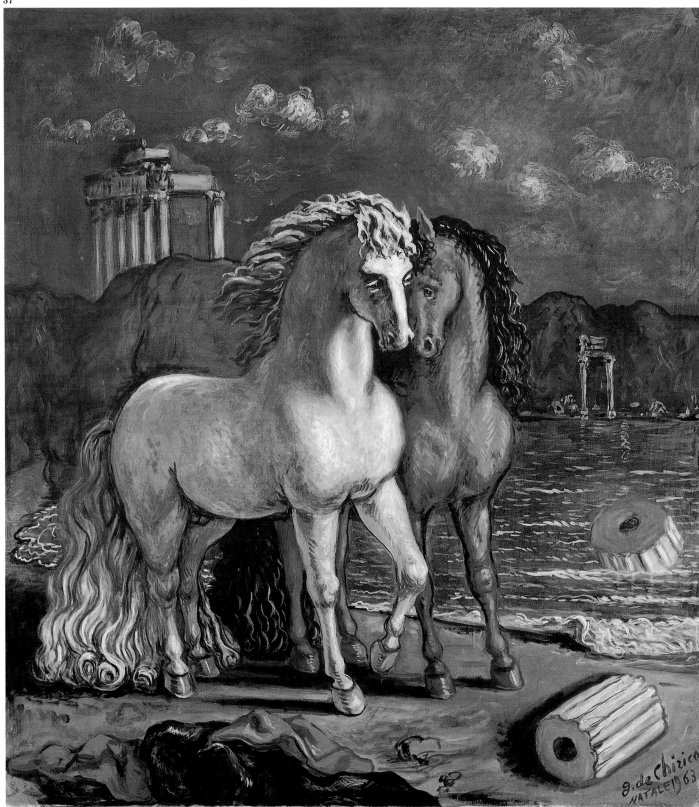

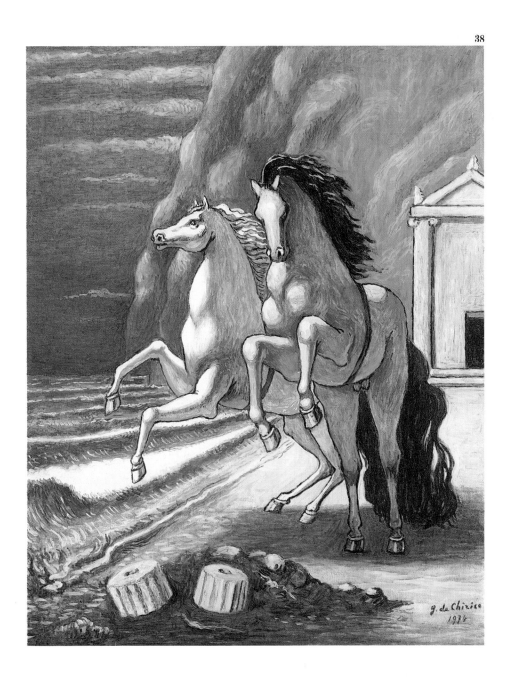

37, 38 Divine Horses of Achilles: Balios and Xanthos, *1963;* The
Horses of Apollo, *1974. De Chirico frequently painted horses
facing one another, a metaphor of Good and Evil in classical
painting. De Chirico explored this theme in many forms
throughout his career, beginning with* The Battle of the Lapiths and
the Centaurs *(plate 1) from his early days, to his later gladiators
in combat.*

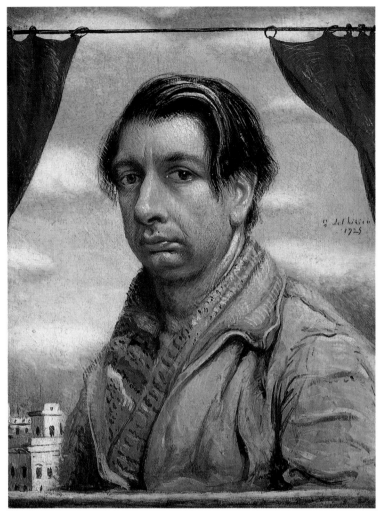

39

The Artist's Own Image

A painter approaches the self-portrait as a reflection not only of him- or herself, but of the craft of painting. De Chirico showed a talent for the genre unmatched among his contemporaries. His impassive gaze, receding chin, and unmistakable nose are as familiar in his iconography as the mannequins, classical busts, or deserted avenues. His extensive series of self-portraits can be seen as a silent and intermittent manifesto about the manner in which de Chirico understood painting throughout his career. The painting of his studio (plate 33), which bows to the seventeenth-century Spanish painter Diego Rodríguez de Silva Velázquez's *Las Meninas* (which is also itself a painted manifesto about the virtue of painting), and those canvases in which he appears in old-fashioned pose or costume, imply an expressive reflection of his attitude toward the pictorial culture of the great classics.

39 Self-Portrait, *1925. The portraits and self-portraits were the first indication, including those before 1920, of the painter's progress toward a classical model. The three-quarter pose, the windowsill below, and the landscape in the background are all reminiscent of Italian Renaissance portraiture.*

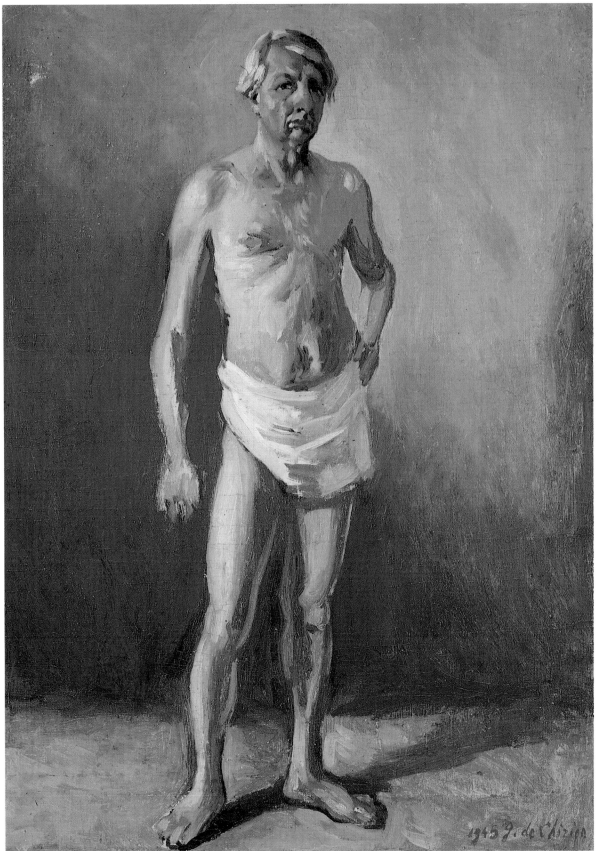

40

40 Nude Self-Portrait, *1945. While exposing himself to the viewer, de Chirico also assumed the role of an anonymous, professional model posing for an academic exercise in portraiture. In the portraits on the following pages, he is also disguised, but in a far more theatrical manner.*

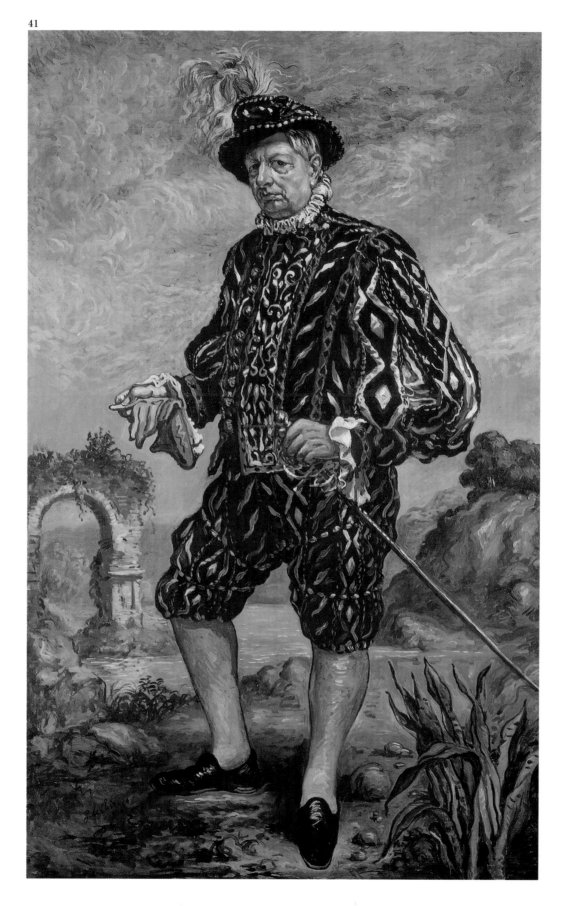

41 Self-Portrait in Black Costume, *1948. Posing himself before a ruin and dressed in a seventeenth-century costume, de Chirico here makes literal his transmutation into a classical painter. As in so many of these portraits, de Chirico followed the original historical model in technique, but imbued it with his own Mannerist commentary.*

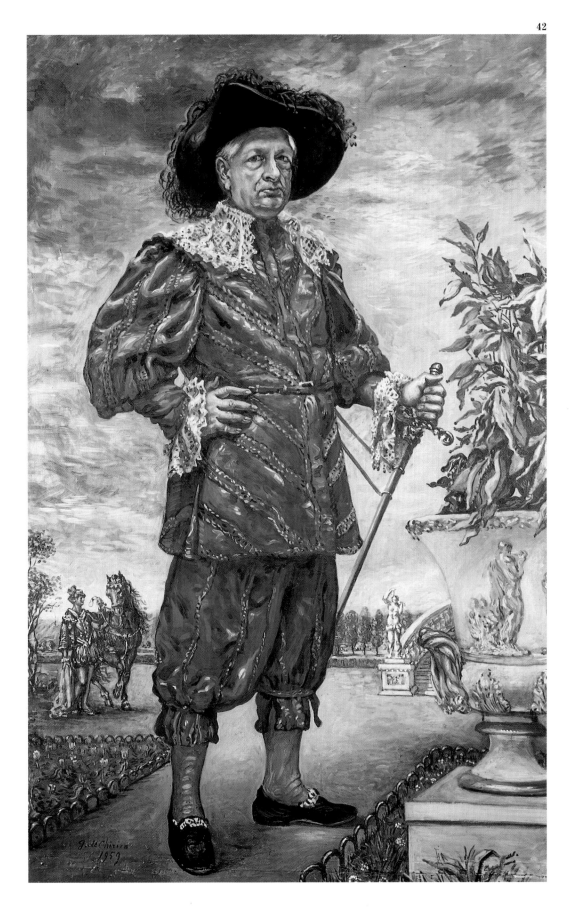

42 Self-Portrait in a Park, *1959. Dressed here in a Flemish costume, the artist was perhaps paying homage to Peter Paul Rubens or Frans Hals. While the background in the previous painting was Arcadian, this is a traditional Italian garden. The setting and the framework faithfully mimic the models of the period, except perhaps for the iron borders that encircle the flower beds, which might well function as an ironic wink.*

The Reinvention of Painting

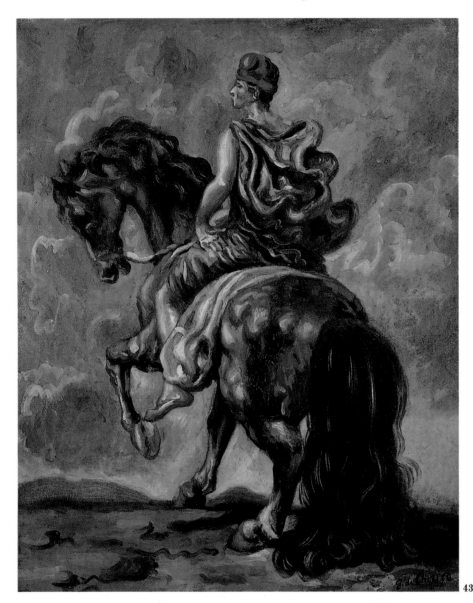

43

The most discussed facet of de Chirico's classical period is the work done "in the manner of," that is, those canvases in which he literally reworked paintings of old masters such as Peter Paul Rubens, Titian, Antoine Watteau, and Jean-Honoré Fragonard. These works constituted not only a personal academic investigation into the techniques of the imitated painters, but also a refined intellectual and rhetorical game. The painter behaved as if he were one of the masters himself. As they sometimes reworked themes from earlier or contemporary paintings, so he reworked their paintings. When he painted himself in costume, de Chirico was trying on the trappings of the old masters, introducing into some of his portraits an unmistakable air of kitsch. The historical vanguard never understood this foray; only recently have critics begun to revise posterity's harsh criticism of it.

43 Horseman with Red Cap and Blue Cape, *1939. The painter combined the horsemen who appear in the piazzas of his Metaphysical paintings with the techniques and colors of the French Romantic painters of the first half of the nineteenth century like Eugène Delacroix and Théodore Géricault.*

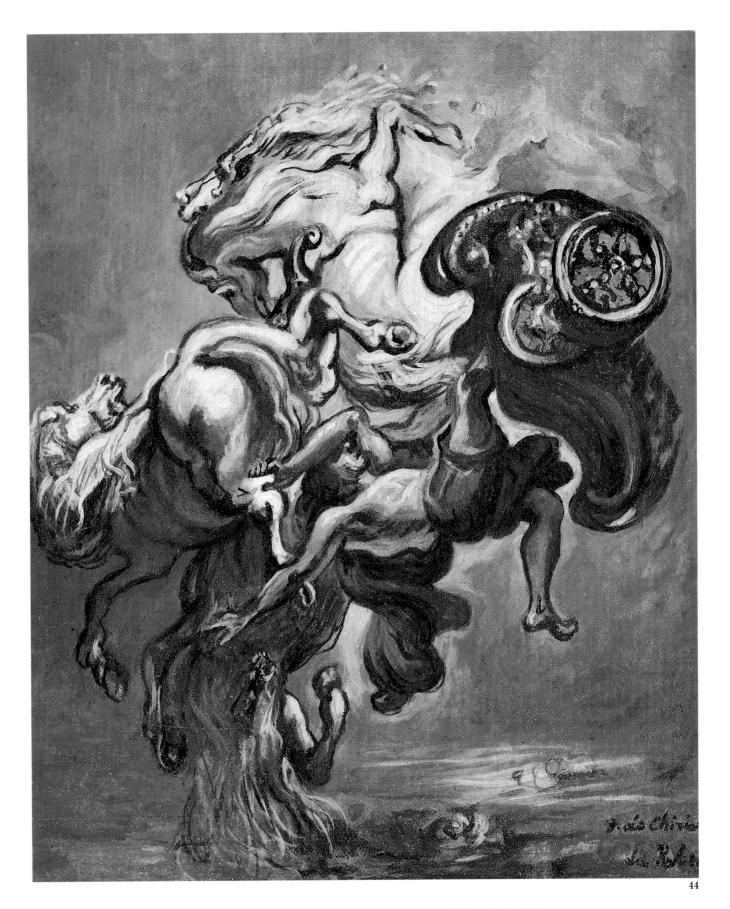

44

44 The Fall of Phaeton (after Rubens), *1954. Like de Chirico's Metaphysical cities, which were "ghosts" of cities, these paintings are "ghosts" of their originals. De Chirico took the ample, sensual style of Rubens but distorted it, introducing a certain distance. The new canvas was thus a definitive de Chirico, rather than a copy of Rubens.*

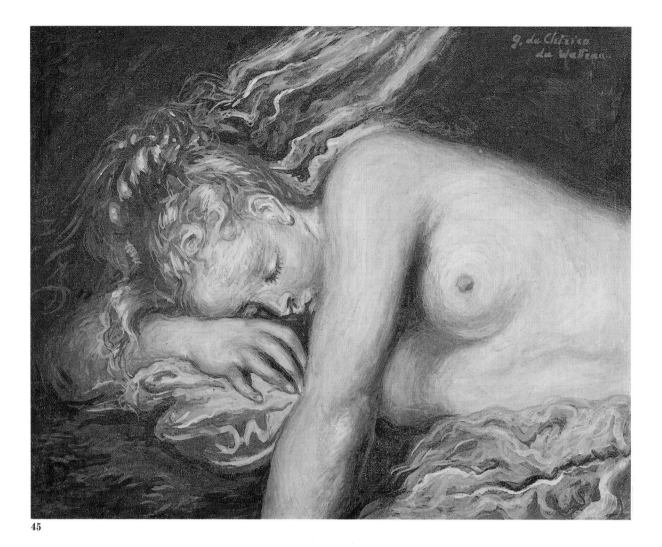

45

45, 46 Sleeping Girl (after Watteau), *1947;* Portrait of a Man (after Titian). *1945. The painters whom de Chirico "reinterpreted" ranged from Raphael, Titian, and Rubens to French Rococo artists. Through his own painting, de Chirico confronted the history of painting as one complete tradition.*

46

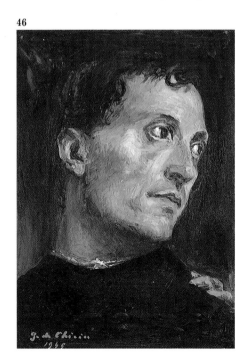

47, 48 Nymph with Triton (after Rubens), *1960;* Mythological Scene, *1960. Using two Rubens paintings as his models, de Chirico manipulated them to express better than ever before how a rupture in the expected can bring new meaning to an image.*

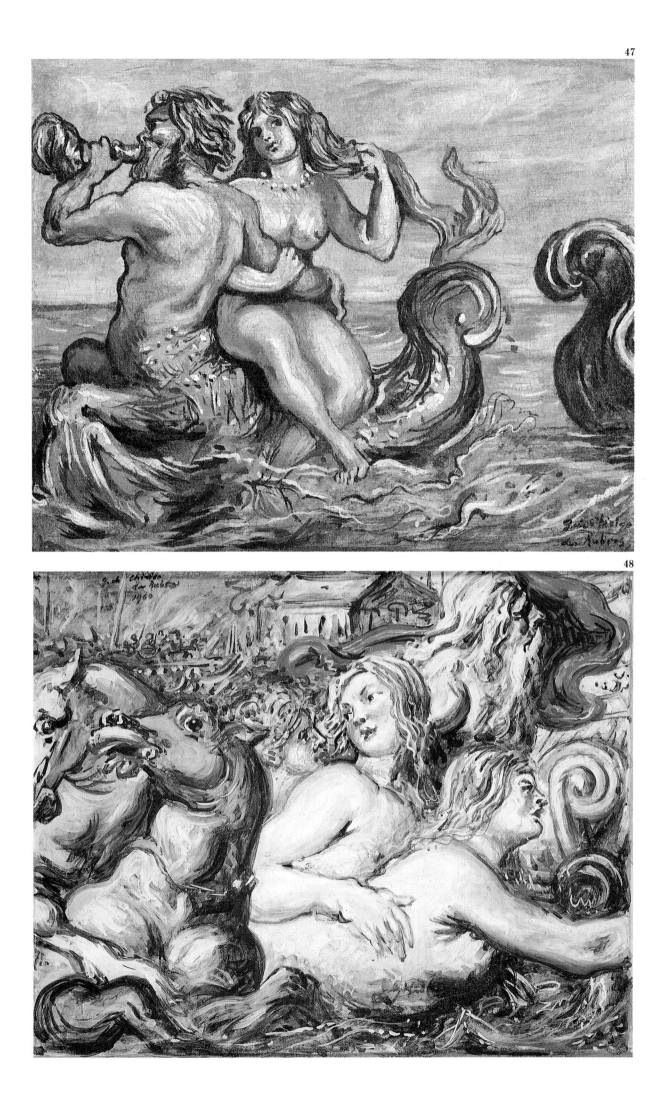

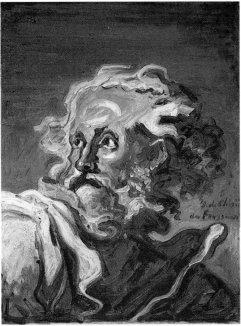

49

49 Old Man's Head (after Fragonard), *c. 1964. When the original paintings selected by de Chirico had little narrative intensity, as is the case here, he focused his attention on the techniques and pictorial modes.*

50, 51 Villa Falconieri, *1946; Villa Medici: Small Temple with Statue, 1945. De Chirico reworked two famous views painted by Velázquez on his second trip to Italy. The small originals are unusual and elusive interpretations of a garden and a traditional landscape. They explore the apparent order of architecture and the hidden order in nature, themes also of interest to de Chirico.*

50

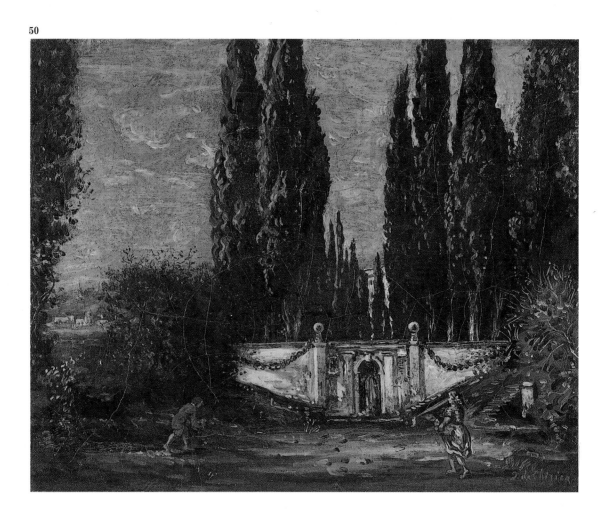

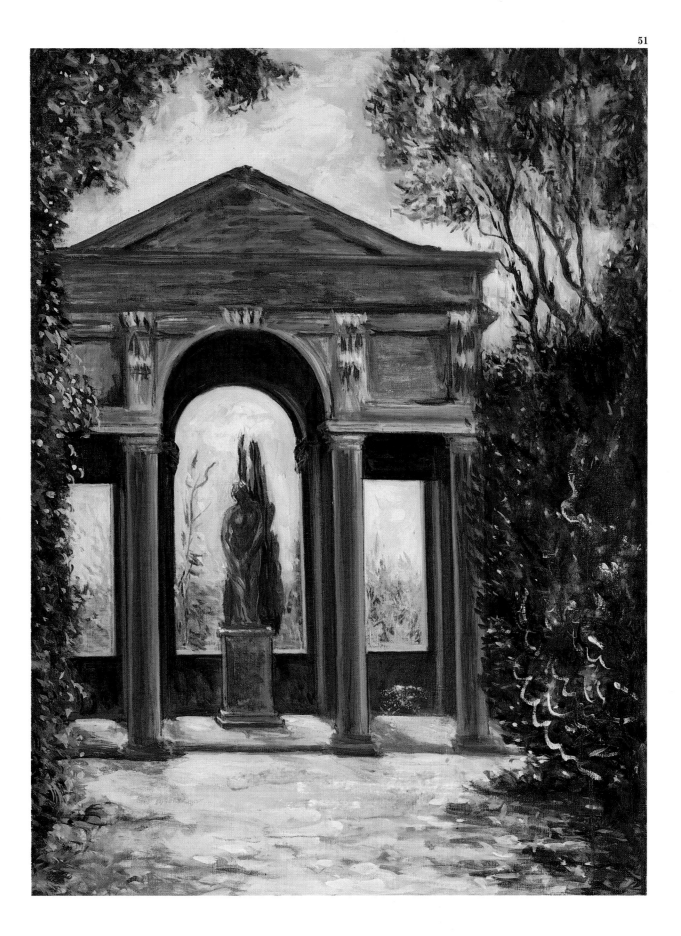

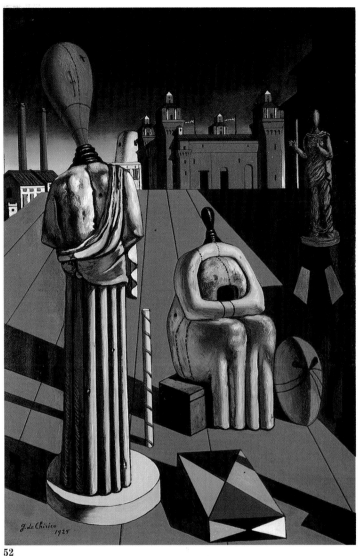

52

Variations on a Theme

De Chirico never ceased to eke out the central mystery of a theme. Not content with reworking paintings from the annals of art history or posing himself as their master, he began to revise his own paintings from the Metaphysical period. From the middle of the 1920s on de Chirico began making new versions of his prewar paintings and also literally copying his Metaphysical paintings. He applied the same naturalness to these exercises as a Baroque or Renaissance workshop producing various canvases with the same religious or heroic image. The process became even more complicated when his paintings mixed Metaphysical imagery with techniques that were classical in origin. Outstanding among these are several post-forties canvases that recall the mechanisms of metamorphosis and the displacement of objects from their habitual context, as in the paintings of the Belgian Surrealist René Magritte.

52 The Disquieting Muses, *1925. De Chirico copied himself here, reproducing one of the most famous paintings of his Ferrara period, painted in 1917. There was no alteration except a somewhat colder and more luminous shading here.*

53 The House within the House, *1924. Magritte was enormously influenced by de Chirico; this painting explores themes such as the conflicting and paradoxical relationship between the interior and exterior, which became a focal point in the work of Magritte.*

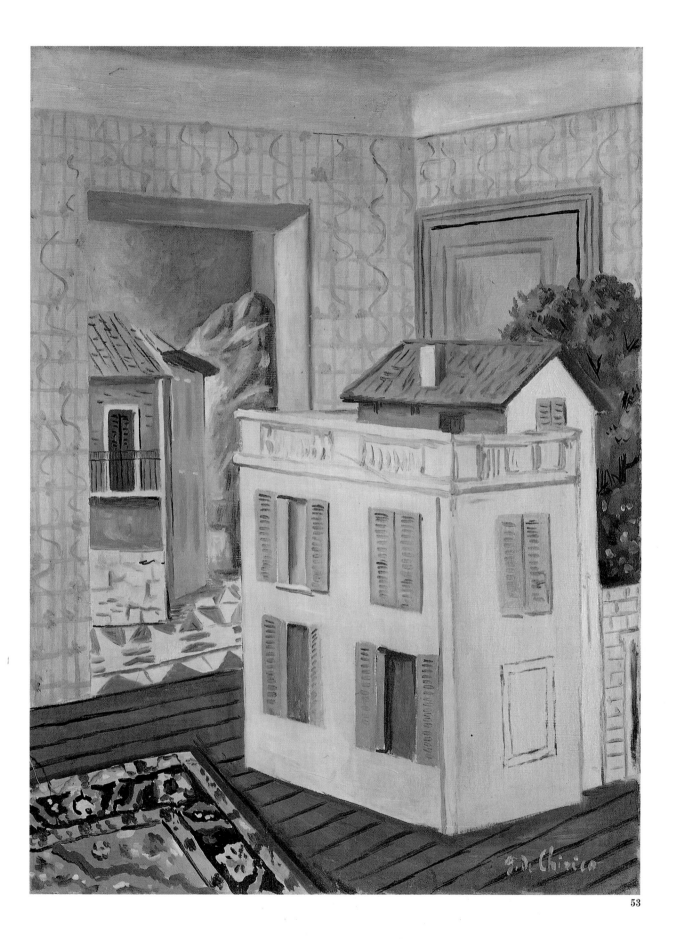

53

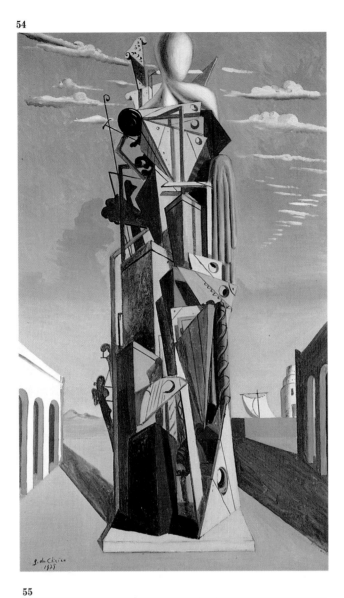

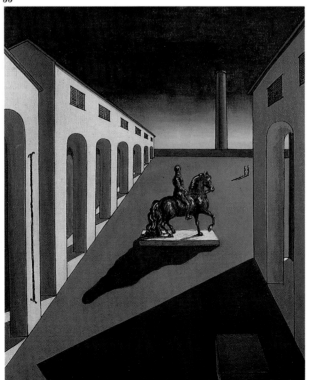

54, 55 The Great Automaton, *1925;* Italian Square with Equestrian Statue, *1936. Two reinterpretations, though not literal, of the Metaphysical universe. The first is a new version of* The Great Metaphysician *(1917; plate 25) with variations in iconography and palette; the second is another work in the Piazza series, one of de Chirico's favorite themes during his Metaphysical period.*

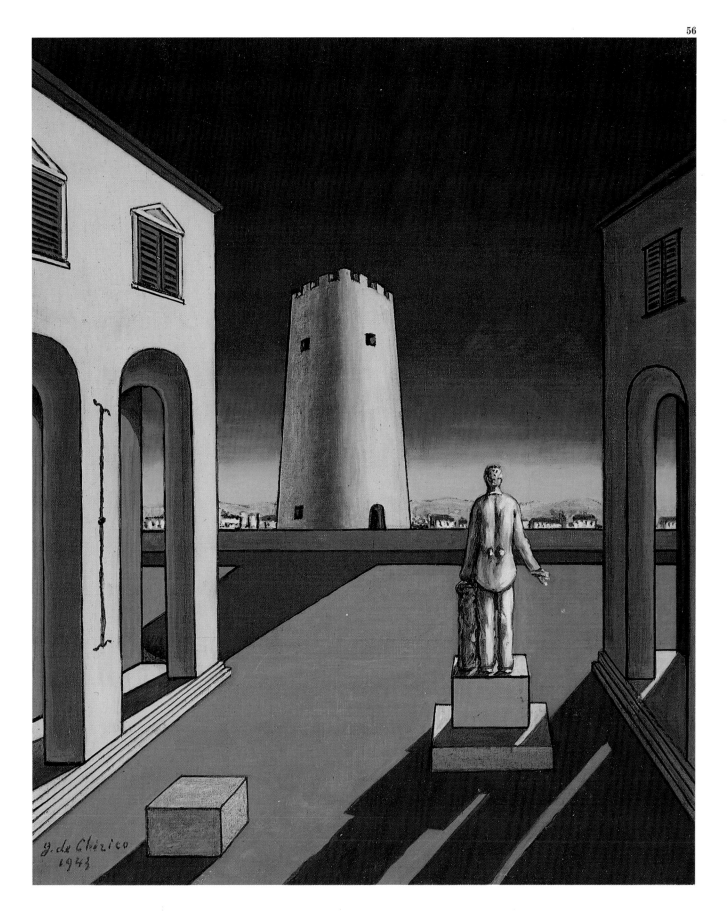

56 Italian Square with Red Tower, *1943. Here de Chirico behaves
with his own paintings as he does with those of the old masters:
reinterpreting the language and iconography with a deceptive
literalness. If within the Platonic tradition, the plastic arts
produced only shadows of shadows, then here it could be said that
we are dealing with the ghost of a previous ghostly vision.*

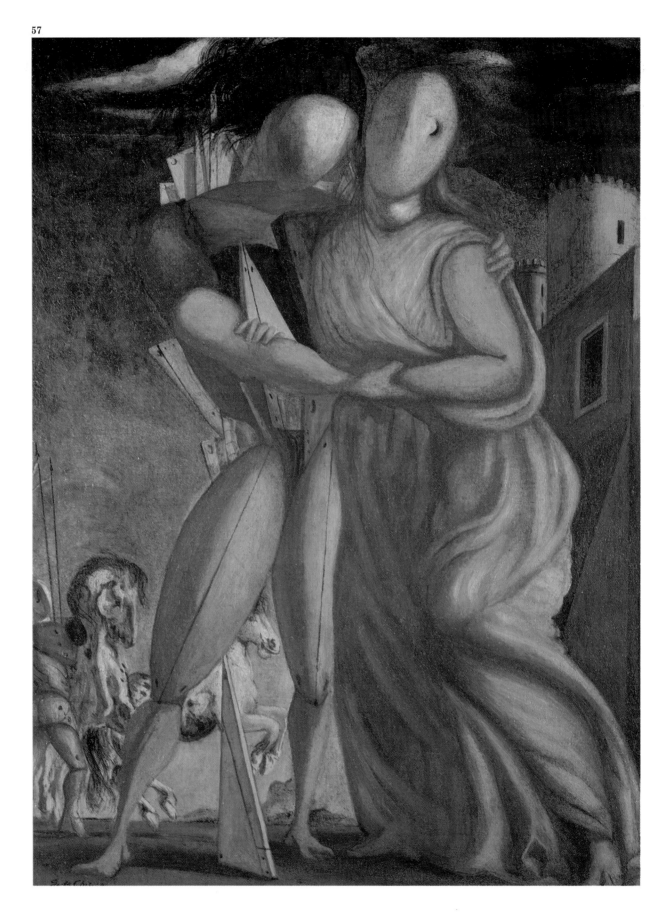

57 Hector and Andromache, *c. 1924. A revealing example of de Chirico's eclectic use of the history of painting. He treats an ancient theme with Metaphysical iconography, converting the characters into mannequins.*

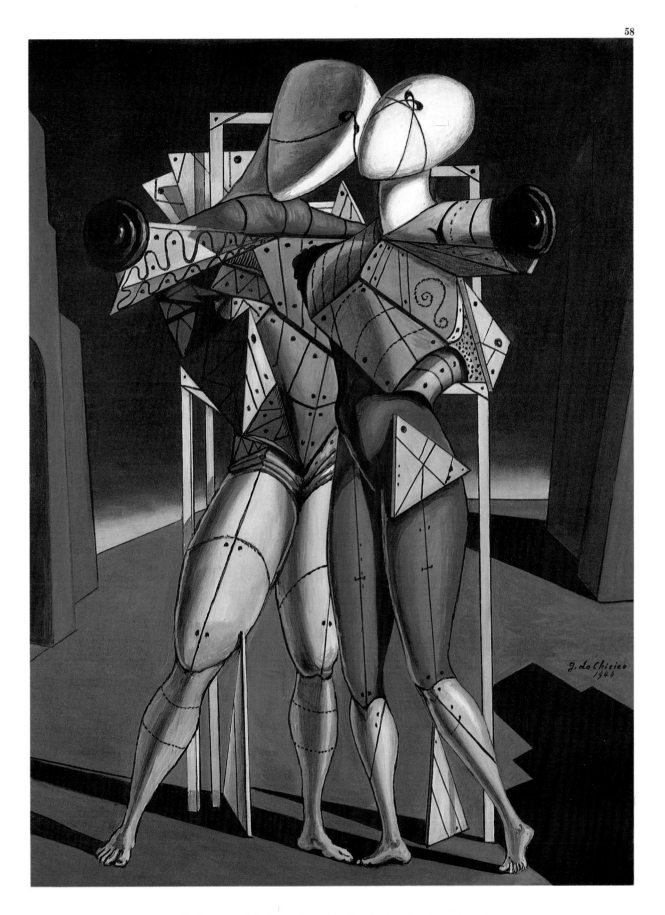

58 Hector and Andromache, *1946. A variation of and counterpart to the previous painting. Hector and Andromache are clearly shown as Metaphysical mannequins; the illumination and use of space are also examples of this style.*

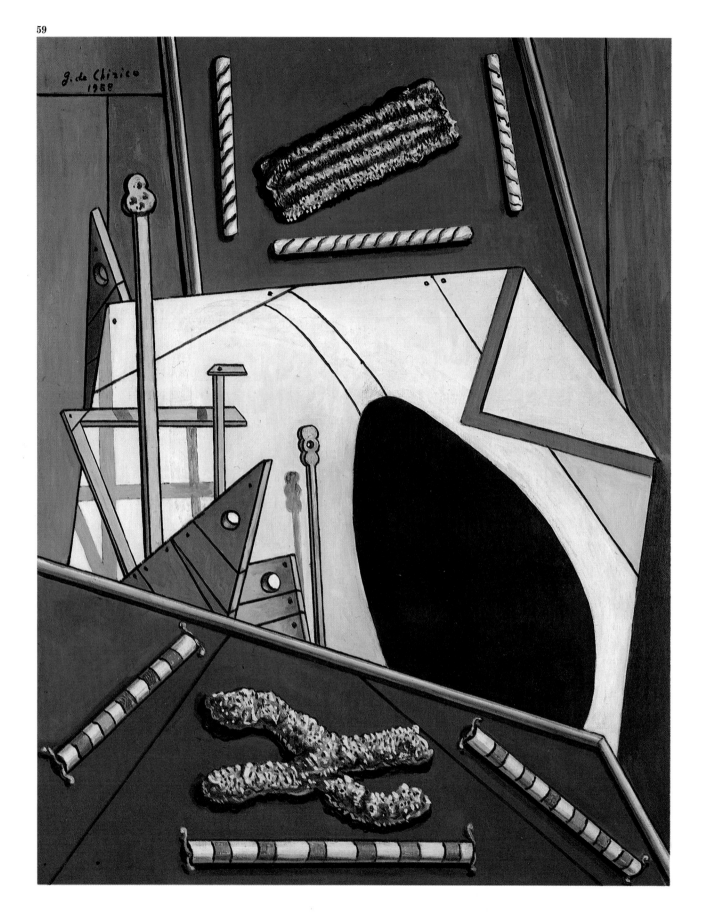

59 Metaphysical Interior with Cookies, *1958. A variation of a painting with the same theme made at the end of World War I. The silhouettes here are made more simply, and the shadows, much closer to a* trompe l'oeil *in the original, are represented and colored in a more schematic manner.*

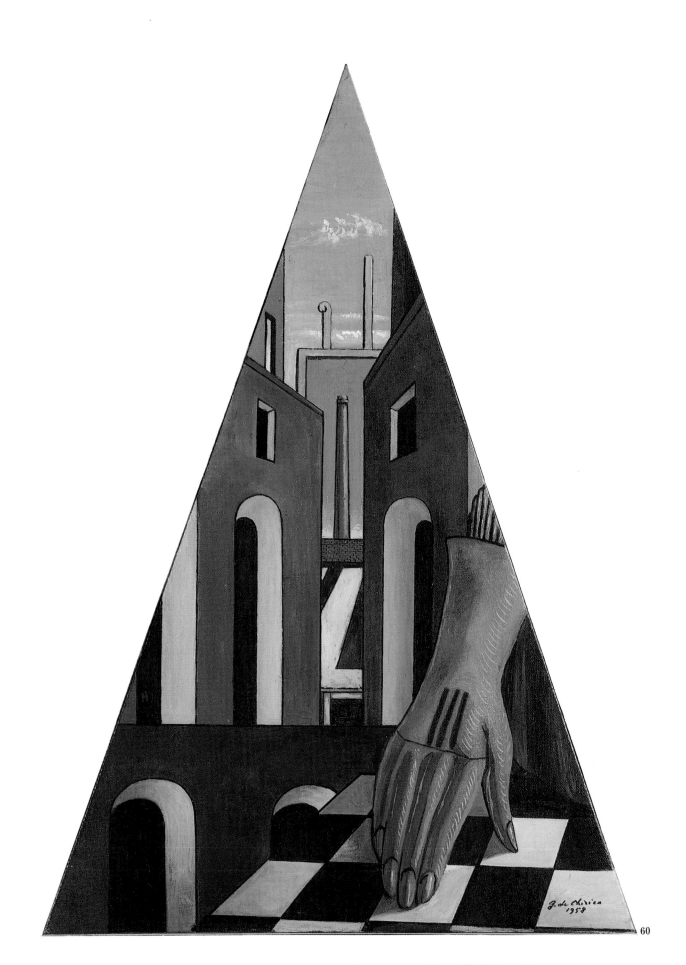

60

60 The Red Glove, *1958. The principal difference between this and* The Enigma of Fatality *(1914; plate 14) is found in the sky: here, it is now a bright daytime sky; in the earlier painting, it was twilight. Much of the mystery of the original painting is diluted as a result.*

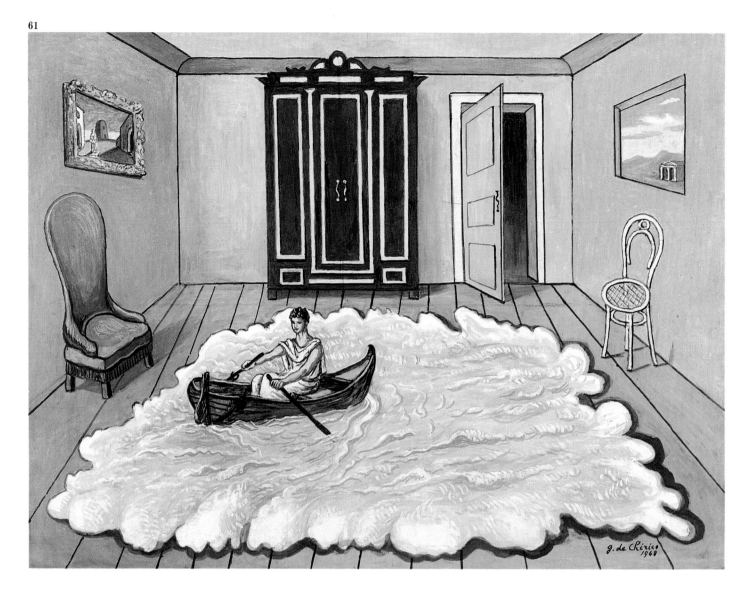

61 The Return of Ulysses, *1968. An example of displacement that became so characteristic of the paintings of Magritte.*

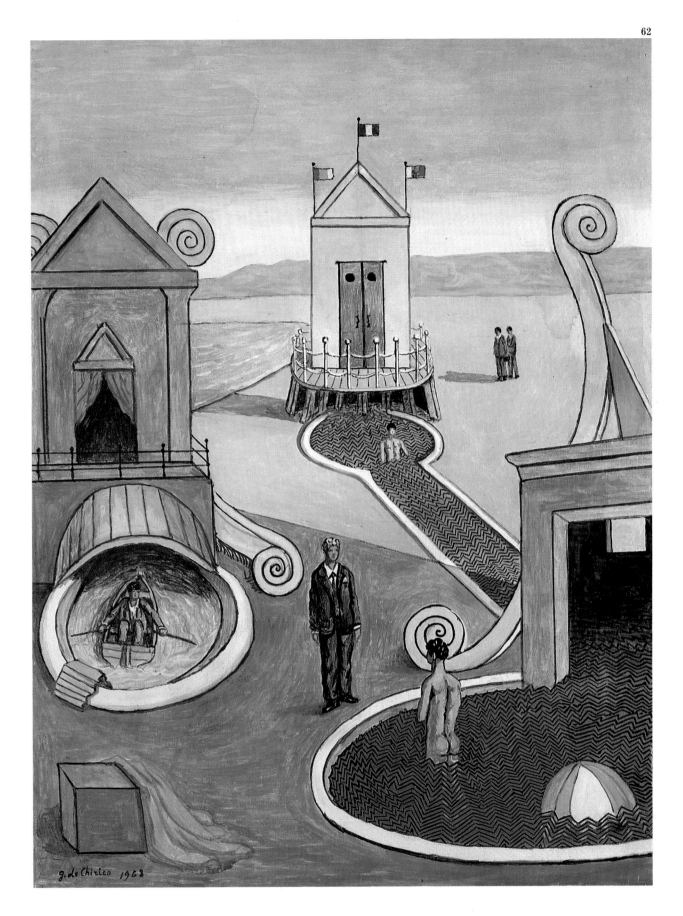

62 Mysterious Baths (Flight to the Sea), *1968. The light, humorous tone of these later paintings counterbalanced the profound anxiety in the works that made him famous during the early decades of the century. This same ironic touch—which can be seen as a sly debunking of his own legacy—characterizes many of de Chirico's later reworkings and newer versions of his Metaphysical paintings.*

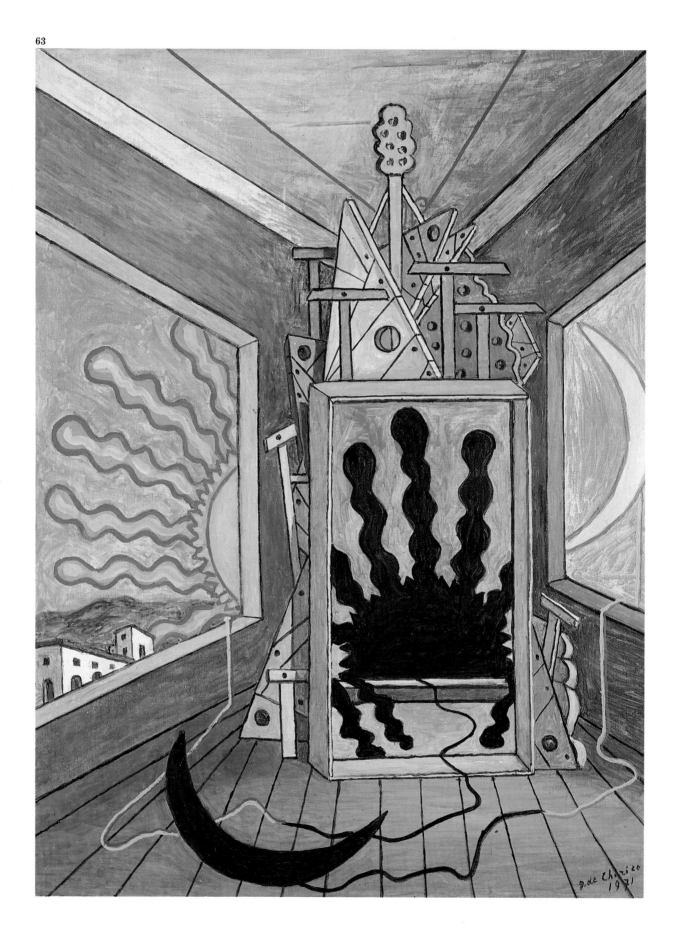

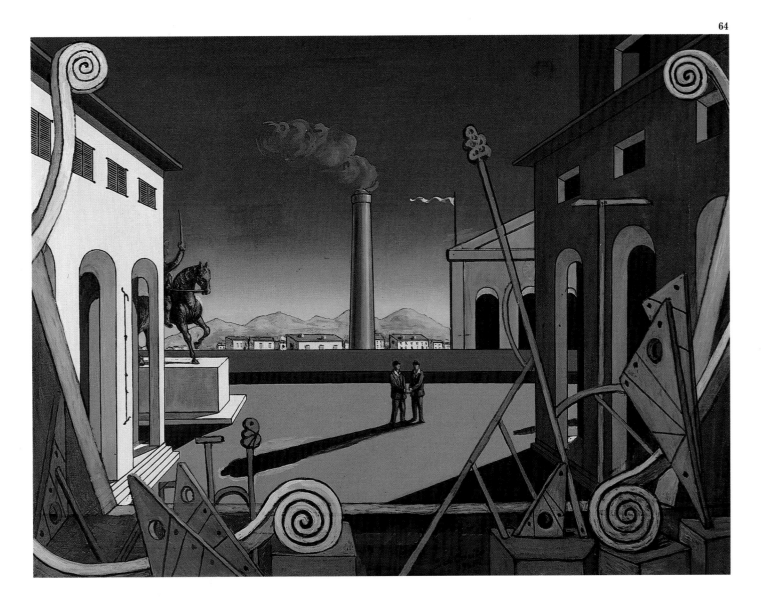

63, 64 Metaphysical Interior with Setting Sun, *1971;* The Great
Game, *1971. The Piazza series and the Metaphysical canvases in
general were dominated by the greenish light of hot autumn
afternoons. Here de Chirico played with suns and
moons connected by strange cables. The elongated shadows and
threatening masses of those paintings, which had confirmed him
as one of the great modern artists, are now diluted. Like an actor
who rises from the stage after the death of his character, de
Chirico thus proclaims, in a mocking manner, his dominion over
a universe that he created and that belongs only to him.*

List of Plates

1 The Battle of the Lapiths and the Centaurs, *1909. Oil on canvas, 29½ × 44⅛″ (75 × 112 cm). Galleria Nazionale d'Arte Moderna e Contemporanea, Rome*

2 Dying Centaur, *1909. Oil on canvas, 46⅛ × 28¾″ (117 × 73 cm). Assitalia Collection, Rome*

3 Portrait of Andrea de Chirico (Alberto Savinio), *1910. Oil on canvas, 46⅞ × 29½″ (119 × 75 cm). Staatliche Museen zu Berlin, Nationalgalerie*

4 Portrait of the Artist's Mother, *1911. Oil on canvas, 33½ × 23⅜″ (85.5 × 62 cm). Galleria Nazionale d'Arte Moderna e Contemporanea, Rome. Gift of Isabella Pakszwer de Chirico*

5 Portrait of Mrs. Gartzen, *1913. Oil on canvas, 28¾ × 23⅝″ (73 × 60 cm). Private collection, Rome*

6 The Enigma of the Arrival and the Afternoon, *1912. Oil on canvas, 27½ × 33⅞″ (70 × 86 cm). Private collection, New York*

7 The Soothsayer's Recompense, *1913. Oil on canvas, 53½ × 71″ (135.9 × 180.4 cm). Philadelphia Museum of Art. The Louise and Walter Arensberg Collection*

8 The Great Tower, *1913. Oil on canvas, 48⅝ × 20¾″ (123.5 × 52.5 cm). Kunstsammlung Nordrhein-Westfalen, Düsseldorf*

9 The Tower, *1913. Oil on canvas, 45½ × 17¾″ (115.5 × 45 cm). Kunsthaus Zürich, Vereinigung Zürcher Kunstfreunde*

10 Gare Montparnasse (The Melancholy of Departure), *1914. Oil on canvas, 55⅛ × 72⅝″ (140 × 184.5 cm). The Museum of Modern Art, New York. Gift of James Thrall Soby*

11 The Evil Genius of a King, *1914–15. Oil on canvas, 24 × 19¾″ (61 × 50.2 cm). The Museum of Modern Art, New York. Purchase*

12 The Mystery and Melancholy of a Street, *1914. Oil on canvas, 34¼ × 28⅛″ (87 × 71.4 cm). Private collection*

13 The Red Tower, *1913. Oil on canvas, 29¾ × 39⅜″ (75.5 × 100 cm). Peggy Guggenheim Collection, Venice. The Solomon R. Guggenheim Foundation, New York*

14 The Enigma of Fatality, *1914. Oil on canvas, 54⅜ × 37⅝″ (138.1 × 95.5 cm). Emanuel Hoffman-Stiftung, Kunstmuseum Basel*

15 The Dream of the Poet, *1914. Oil and charcoal on canvas, 35 × 15¾″ (88.9 × 40 cm). Peggy Guggenheim Collection, Venice. The Solomon R. Guggenheim Foundation, New York*

16 Portrait of Guillaume Apollinaire, *1914. Oil on canvas, 32⅛ × 25⅝″ (81.5 × 65 cm). Musée National d'Art Moderne, Centre Georges Pompidou, Paris*

17 The Child's Brain, *1914. Oil on canvas, 32 × 25½″ (82 × 64.7 cm). Moderna Museet, Stockholm*

18 The Anguish of Departure, *1913–14. Oil on canvas, 33½ × 27¼″ (85 × 69.2 cm). Albright-Knox Art Gallery, Buffalo, New York. Room of Contemporary Art Fund*

19 The Philosopher's Conquest, *1914. Oil on canvas, 49½ × 39½″ (125.7 × 100.3 cm). The Art Institute of Chicago. The Joseph Winterbotham Collection*

20 The Song of Love, *1914. Oil on canvas, 28¾ × 23⅜″ (73 × 59.1 cm). The Museum of Modern Art, New York. Nelson A. Rockefeller Bequest*

21 The Seer, *1915. Oil on canvas, 35¼ × 27⅝″ (89.6 × 70.1 cm). The Museum of Modern Art, New York. James Thrall Soby Bequest*

22 The Melancholy of Departure, *1916. Oil on canvas, 20⅜ × 14¼″ (51.8 × 36 cm). The Trustees of the Tate Gallery, London*

23 The Gentle Afternoon, *1916. Oil on canvas, 25¼ × 23″ (64 × 58.4 cm). Peggy Guggenheim Collection, Venice. The Solomon R. Guggenheim Foundation, New York*

24 The Greetings of a Distant Friend, *1916. Oil on canvas, 19 × 14½″ (48.2 × 36.5 cm). Private collection*

25 The Great Metaphysician, *1917. Oil on canvas, 41⅛ × 27½″ (104.5 × 69.8 cm). The Museum of Modern Art, New York. The Philip L. Goodwin Collection*

26 The Sacred Fish, *1919. Oil on canvas, 29½ × 24⅜″ (74.9 × 61.9 cm). The Museum of Modern Art, New York. Acquired through the Lillie P. Bliss Bequest*

27 The Pregnant Woman (after Raphael), *1920. Oil on wood panel, 25½ × 19¼″ (65 × 49 cm). Galleria Nazionale d'Arte Moderna e Contemporanea, Rome. Gift of Isabella Pakszwer de Chirico*

28 Saint George, *1920. Oil on canvas, 13¾ × 9½″ (35 × 24 cm). Casella Collection*

29 Lucretia, *1922. Oil on canvas, 68½ × 30″ (174 × 76 cm). Galleria Nazionale d'Arte Moderna e Contemporanea, Rome. Gift of Isabella Pakszwer de Chirico*

30 The Poet's Farewells (Tibullus and Messala), *1923. Tempera on canvas, 25 × 19½″ (64 × 49.5 cm). Mario Cambi Collection, Rome*

31 The Shores of Thessaly, *1926. Oil on canvas, 36¼ × 28¾″ (92 × 73 cm). Private collection*

32 Gladiators, *1928. Oil on canvas, 63 × 37⅜″ (160 × 95 cm). Private collection, Rome*

33 The Master's Studio in Paris, *c. 1933–34. Oil on canvas, 21⅞ × 18¼″ (55.5 × 46.5 cm). Galleria Nazionale d'Arte Moderna e Contemporanea, Rome. Gift of Isabella Pakszwer de Chirico*

34 The Via Appia, *c. 1954. Oil on canvas, 19⅝ × 23⅝″ (50 × 60 cm). Private collection, Rome*

35 Rural Scene with Landscape, *c. 1960. Oil on canvas, 42⅛ × 30″ (107 × 76 cm). Private collection, Rome*

36 Horsemen with Horses by the Sea, *c. 1960. Oil on canvas, 30 × 42⅛″ (76 × 107 cm). Private collection, Rome*

37 Divine Horses of Achilles: Balios and Xanthos, *1963. Oil on canvas, 38⅝ × 34¼″ (98 × 87 cm). Private collection, Rome*

38 The Horses of Apollo, *1974. Oil on canvas, 36⅜ × 28¾″ (92.5 × 73 cm). Private collection, Rome*

39 Self-Portrait, *1925. Oil on cardboard, 24⅝ × 18⅛″ (62.5 × 46 cm). Galleria Nazionale d'Arte Moderna e Contemporanea, Rome*

40 Nude Self-Portrait, *1945. Oil on canvas, 22 × 16½″ (56 × 42 cm). Giorgio and Isa de Chirico Foundation, Rome. Gift of Isabella Pakszwer de Chirico*

41 Self-Portrait in Black Costume, *1948. Oil on canvas, 60 × 35¼″ (152.5 × 89.5 cm). Galleria Nazionale d'Arte Moderna e Contemporanea, Rome.*

42 Self-Portrait in a Park, *1959. Oil on canvas, 60¼ × 38⅝″ (153 × 98 cm). Private collection, Rome*

43 Horseman with Red Cap and Blue Cape, *1939. Oil on paper on cardboard, 18⅛ × 15″ (46 × 38 cm). Galleria Nazionale d'Arte Moderna e Contemporanea, Rome*

44 The Fall of Phaeton (after Rubens), *1954. Oil on canvas, 19⅝ × 15¾″ (50 × 40 cm). Private collection, Rome*

45 Sleeping Girl (after Watteau), *1947. Oil on canvas, 15¾ × 19⅝″ (40 × 50 cm). Private collection, Rome*

46 Portrait of a Man (after Titian), *1945. Oil on cardboard, 12¼ × 9″ (31 × 23 cm). Private collection, Paris*

47 Nymph with Triton (after Rubens), *1960. Oil on canvas, 15¾ × 19⅝″ (40 × 50 cm). Private collection, Rome*

48 Mythological Scene (after Rubens), *1960. Oil on canvas, 15¾ × 19⅝″ (40 × 50 cm). Giorgio and Isa de Chirico Foundation, Rome*

49 Old Man's Head (after Fragonard), *c. 1964. Oil on canvas, 19⅝ × 15¾″ (50 × 40 cm). Private collection, Rome*

50 Villa Falconieri, *1946. Oil on canvas, 15¾ × 19⅝″ (40 × 50 cm). Private collection, Rome*

51 Villa Medici: Small Temple with Statue, *1945. Oil on canvas, 23⅝ × 17⅜″ (60 × 44 cm). Private collection, Rome*

52 The Disquieting Muses, *1925. Oil on canvas, 38⅛ × 26⅜″ (97 × 67 cm). Galleria Nazionale d'Arte Moderna e Contemporanea, Rome*

53 The House within the House, *1924. Oil on canvas, 28¾ × 20⅞″ (73 × 53 cm). Mario Cambi Collection, Rome*

54 The Great Automaton, *1925. Oil on canvas, 43⅜ × 25⅝″ (110 × 65 cm). Museum of Honolulu*

55 Italian Square with Equestrian Statue, *1936. Oil on canvas, 23⅝ × 19⅝″ (60 × 50 cm). Private collection, Rome*

56 Italian Square with Red Tower, *1943. Oil on canvas, 19⅝ × 15¾″ (50 × 40 cm). Private collection, Rome*

57 Hector and Andromache, *c. 1924. Oil on canvas, 38¾ × 29⅜″ (98.5 × 74.5 cm). Galleria Nazionale d'Arte Moderna e Contemporanea, Rome*

58 Hector and Andromache, *1946. Oil on canvas, 32¼ × 23⅝″ (82 × 60 cm). Private collection, Rome*

59 Metaphysical Interior with Cookies, *1958. Oil on canvas, 25⅝ × 19⅝″ (65 × 50 cm). Private collection, Rome*

60 The Red Glove, *1958. Oil on canvas, 28⅜ × 18⅞″ (72 × 48 cm). Private collection, Rome*

61 The Return of Ulysses, *1968. Oil on canvas, 23⅝ × 31½″ (60 × 80 cm). Private collection, Rome*

62 Mysterious Baths (Flight to the Sea), *1968. Oil on canvas, 31½ × 23⅝″ (80 × 60 cm). Private collection, Rome*

63 Metaphysical Interior with Setting Sun, *1971. Oil on canvas, 31½ × 23⅝″ (80 × 60 cm). Private collection, Rome*

64 The Great Game (Italian Square), *1971. Oil on canvas, 23⅝ × 31½″ (60 × 80 cm). Private collection, Paris*

Series Coordinator, English-language edition: Ellen Rosefsky Cohen
Editor, English-language edition: Sarah Burns
Designer, English-language edition: Judith Michael

Page 1 The Mathematicians, *1917. Pencil on paper, $12^{5}/_{8} \times 8^{5}/_{8}''$*
(32 × 22 cm). The Museum of Modern Art, New York.
Gift of Mrs. Stanley B. Resor

ISBN 0–8109–4686–6

Published in 1995 by Harry N. Abrams, Incorporated, New York
A Times Mirror Company

Printed and bound in Spain by La Polígrafa, S.L.
Parets del Vallès (Barcelona)
Dep. Leg.: B. 22.008-1995